IN

COMPANY

OF

REDWOODS

Text and Photography
by David Casterson

Natural Sight Press
Aptos, California

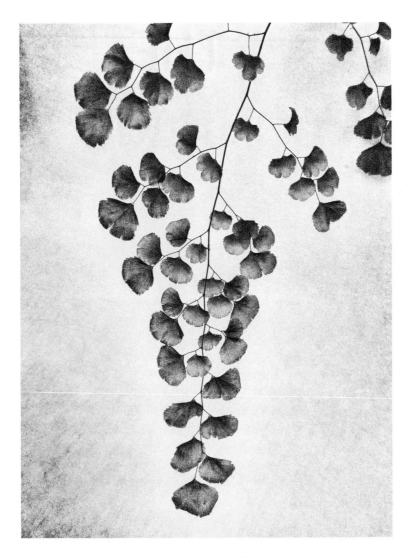

Natural Sight Press
Aptos, California
ISBN: 978-1-4951-0660-6

First Printing: March 2014
Second Printing: May 2014

Cast of Characters

Bloom	Common Name	Scientific name	Page
Mar-Jun	Big Leaf Maple	*Acer macrophyllum*	58
Mar-Jun	Red Clintonia	*Clintonia andrewsiana*	60
Mar-Jul	Calif. Blackberry	*Rubus ursinus*	62
Mar-Aug	Thimbleberry	*Rubus parviflorus*	64
Mar-Aug	Wild Ginger	*Asarum caudatum*	66
Mar-Aug	Brook Foam	*Boykinia occidentalis*	68
Apr-May	Douglas Fir	*Pseudotsuga menziesii*	70
Apr-Jun	Pacific Starflower	*Trientalis latifolia*	72
Apr-Jun	Poison Oak	*Toxicodendron diversilobum*	74
Apr-Jun	Vanilla Leaf	*Achlys triphylla*	76
Apr-Jul	Cow Parsnip	*Heracleum maximum*	78
Apr-Jul	Salal	*Gaulheria shallon*	80
Apr-Jul	Elk Clover	*Arali californica*	82
Apr-Jul	Wood Rose	*Rosa gymocarpa*	84
Apr-Aug	Inside-out Flower	*Vancouveria planipetala*	86
Apr-Aug	Calif. Azalea	*Rhododendron occidentale*	88
Apr-Sep	Crimson Columbine	*Aquilegia formosa*	90
Apr-Sep	Yerba Buena	*Satureja douglasii*	92
Apr-Sep	Wood Mint	*Stachys bullata*	94
May-Jul	Bracken Fern	*Pteridium aquilinum*	96
May-Oct	Trail Plant	*Adenocaulon bicolor*	98
May-Oct	Stinging Nettle	*Urtica dioica*	100
Jun-Aug	Five Finger Fern	*Adiantum aleuticum*	102
Jun-Oct	Tan Oak	*Notholithocarpus densiflorus*	104
Jun-Nov	Mugwort	*Artemisia douglasiana*	106

Coast Redwood

First evolving 240 million years ago, for the last 10,000 years, Coast Redwoods have only grown within a narrow fog band along the Pacific Coast, from southern-most Oregon to Monterey County in Central California. Fossilized Redwoods several millions of years old can been found through-out the northern hemisphere including Arizona, Europe and China. The species name sempervirens means forever living, referring to the tree's resistance to insects, fungus, fire, and drowning. The cells of most living things, including humans have two sets of chromosomes, one from each parent. Coast Redwoods have six sets and some scientists suggest that this has enabled them to accumulate the mutations necessary to produce their multitude of resistance strategies.

A Redwood's dark green needles are sharp pointed and its fibrous cinnamon-brown bark is twenty cm thick. Most large Redwoods range from 50-75m tall, but a 2000 year old specimen can be up to 120m. The Coast Redwood becomes reproductively mature at about ten years. The male yellow flowers produce pollen which is carried by the wind to greenish female flowers, causing them to grow into small cones that ripen in the Fall, with fifty tiny, poorly germinating seeds each. The Coastal Redwood is also able to reproduce from the trunk of cut 'mother' trees, forming a 'fairy ring' like the one on the cover of this fieldbook. Lying on your back at the center of one of these rings and looking up is perhaps the best way to feel what is like to be in the company of Redwoods. 6

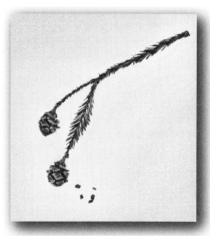

To see the seeds, shake a cone on white paper

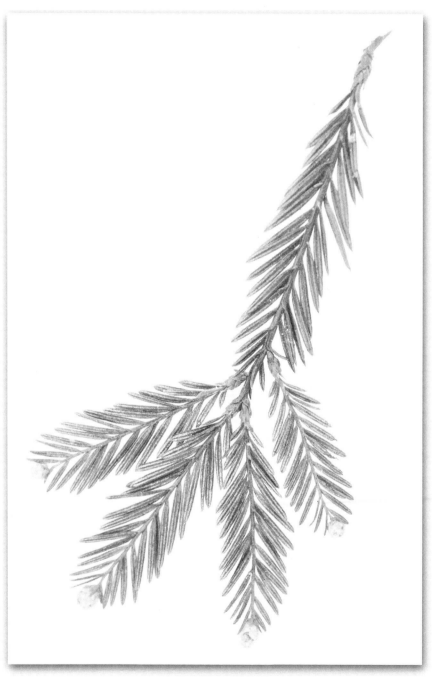

Coast Redwood
Sequoia sempervirens

7

California Milk Maids

The Milk Maid's flowers are one of the first to appear each winter in the Redwood Community, and for me, mark the beginning of the new year of life. For this reason, I consider this graceful plant to be an especially welcoming friend! The flower closes its petals in late afternoon as the sun goes down and the thin stem supporting the flower nods before a rain. The white to pale rose flowers of Milk Maids have four small petals, which are protected in their development by four sepals, the outer covering of the bud that later supports the blooming petals. The leaves are highly variable in shape, with three to five thin leaves per leaflet along the slender stem, and broad arrowhead shaped leaves with a maroon underside lower on the stem near the ground. Milk Maids love moist, shaded slopes and the edges of a trail.

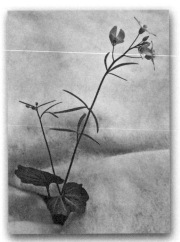

Why do many plants close their flowers at night?

Common names can be confusing, because one species often has several of them, and unrelated plants can have names that are similar (e.g. the Douglas fir, Pseudotsuga menziensii, is not at all closely related to the Silver Fir, Abies amabis). The common name 'Milk Maids' refers to its resemblance to milk maid's clothing. Its other common name of 'Toothwort', may come from the tooth-like appearance of the root of the plant, or its use as a remedy for toothache. Scientific names are hard to pronounce and spell (I owe my high school Latin teacher much for her patience), but each species has just one scientific name. The scientific name is used by scientists of all languages and is a two part italicized Latin name, with the genus name capitalized and the species name all lowercase. Occasionally scientific names are changed to better reflect a species' relationship to related plants.

8

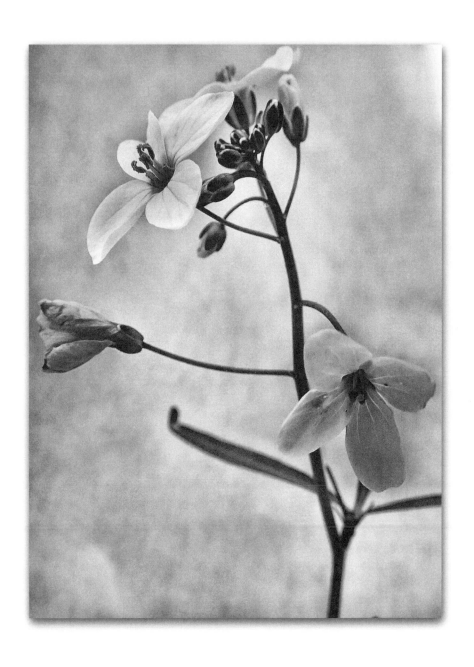

California Milk Maids
Cardamine californica

Western Sword Fern

Sword Ferns were quite possibly among the first plants to join the company of Redwoods, and are the most prevalent fern you will find in this forest. Its common name comes from the resemblance of the small projection at the base of each blade to the hilt of a sword. The blades of its fronds have serrated edges like a knife.

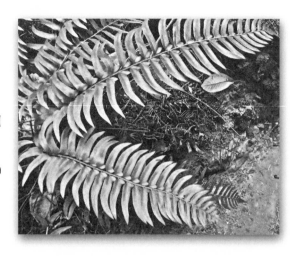

Coast Redwood's constant companion

Sword ferns and all their relatives reproduce by making spores in the sori found seasonally on the undersides of their leaf blades. The shape and pattern of the sori can be used for identification. Sword ferns also reproduce by forming buds that make new plants. Because of this ability, they can live in slightly drier habitats than other ferns, preferring the shaded, close company of Redwoods over the wet rock outcroppings and stream edges that other ferns chose.

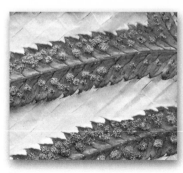

Find the serrations and hilt

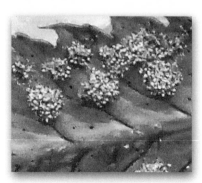

Round sori packed with spores

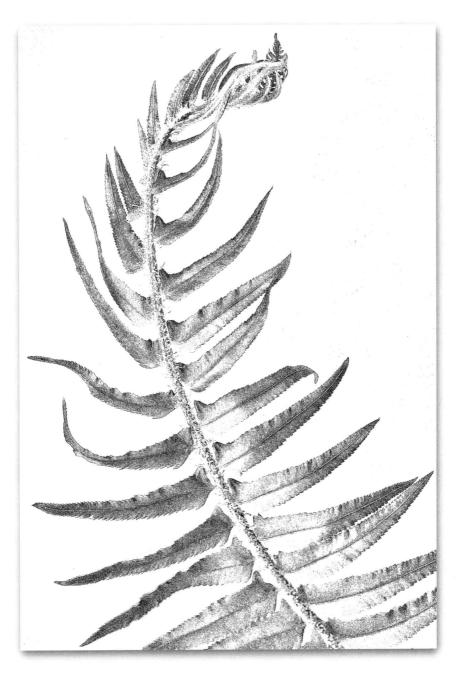

Western Sword Fern
(*Polystichum munitum*)

11

California Hazel

Hanging from bare twigs, the catkins of the California Hazel sway in late Fall winds, beckoning like the promise of Spring. Their pollen is released Jan-Mar when the tiny female flowers with their showy scarlet pistils emerge and are pollinated by the wind. Dispersed by rodents and Blue Jays, Hazel's tasty nuts mature September-October. Germination takes place when a plant hormone present in the husk of the hazel nut breaks down. This deciduous open shrub stands two to four meters tall, often forming multiple smooth gray-brown barked trunks. Its branches bear alternate leaves with double-saw toothed edges and rounded bases.

Hazel with last year's nut inside its husk and with this year's catkin

The California Hazel prefers open and shaded wooded slopes and moist areas along creeks in the Pacific Coastal Range, but not direct exposure to salt air. The California Hazel resprouts readily after a fire, in fact, the First People often used fire to remove surrounding brush, stimulating its growth. Hazel is easily transplanted, long lived and tolerates humans better than most native plants, perhaps due to its thousands of years of use by the First People.

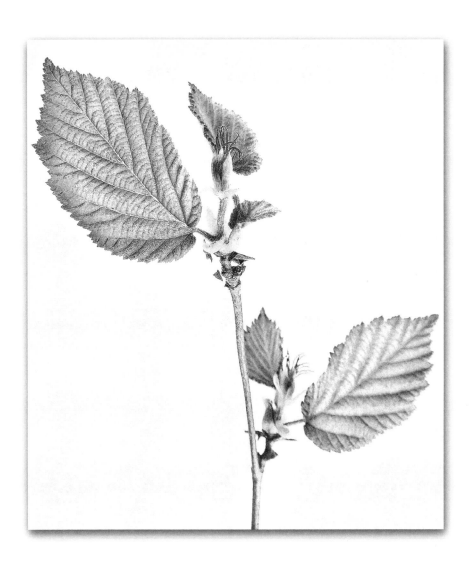

California Hazel
(*Corylus cornuta*)

Fetid Adder's Tongue

This elegant beauty prefers the colder areas of the forest. Its short-lived blossoms can be easily missed by those staying inside warm houses in early winter. But the moment your eyes rest upon its magenta striped, cream colored <u>petals</u> may well be the beginning of a lifelong love. With a little imagination, one can see a

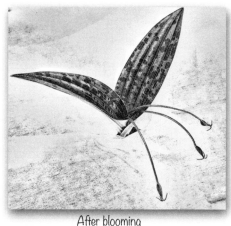

After blooming

resemblance of its flower to the open mouth of the poisonous adder snake with its stamens a three-forked tongue hissing at us. It is delightful to look upon but has <u>evolved</u> a rotting flesh smell very effective in attracting flies for <u>pollination</u>.

"Fetid Adder's Tongue's one pair of leaves are parallel-veined and glossy, with brownish-purple splotches, like someone spilled motor oil on them." This was the unkind description I wrote in my notebook when I first saw this plant in my college Spring quarter field biology class. If I had seen Fetid Adder's Tongue blooming in February, I am sure I would have been more poetic.

Walter Albion Squires wrote in 1906, "Under some giant of the forest...one is apt to find a colony of Scoliopus...dispelling the book-learned theory that all nature is a heartless 'struggle for existence'. The forest is a world of plant cooperation and helpfulness. The removal of the trees means death to many humble dwellers of the shade, and when the lowly vegetation of the forest floor is destroyed by sheep, fire or cultivation, the lofty monarchs of the forest sicken and die." Walking among the Redwood forest a century ago, he saw it as an interdependent whole, as I do.

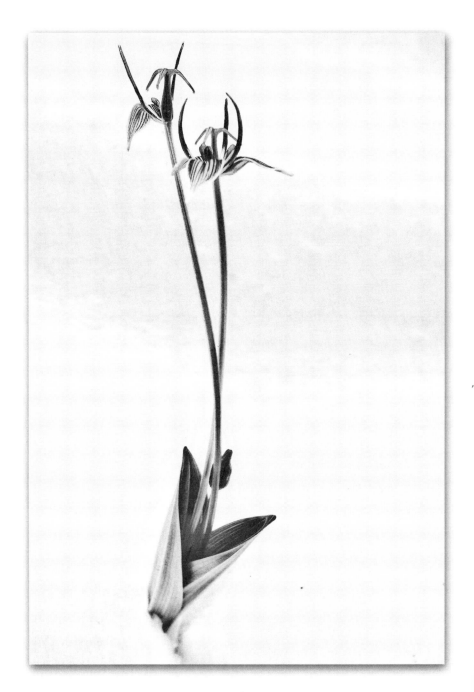

Fetid Adder's Tongue
(*Scoliopus bigelovii*)

15

Common Horsetail

This is one of the 20 surviving
species of the Horsetail Family,
which was found nearly worldwide
when dinosaurs roamed our planet.
They are one of Earth's oldest
plants; extinct forms reached 15 m
tall and covered vast sections of
the Earth 360 million years ago.
In Latin, 'equus' means horse, which
finds its way into English in the
word equestrian and is the basis for
the genus name, Equisitum.

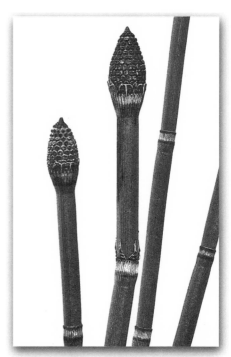

Why are horsetails found in moist places?

Five of the surviving species of Equisetum live in the company of Redwoods.
Common Horsetail's spores are produced by the cone-like structure at the tip
of the stem, and, like most ferns and fern allies, they require moisture for
fertilization. Broken into sections, their jointed, hollow stems can be played in
pan flute fashion by blowing over the open ends. Each section yields a
different note as the diameter decreases and with practice, I have been able to
play the song 'London Bridge is Falling Down'.

You will find the Common Horsetail along streams and seasonal bogs,
occasionally growing in large colonies. Horsetails have the ability to
concentrate gold and other heavy metals in their tissues, but not to the degree
needed to support commercial extraction. Horsetails are described by
biologists as dimorphic, meaning that they form both sterile and fertile plants.

16

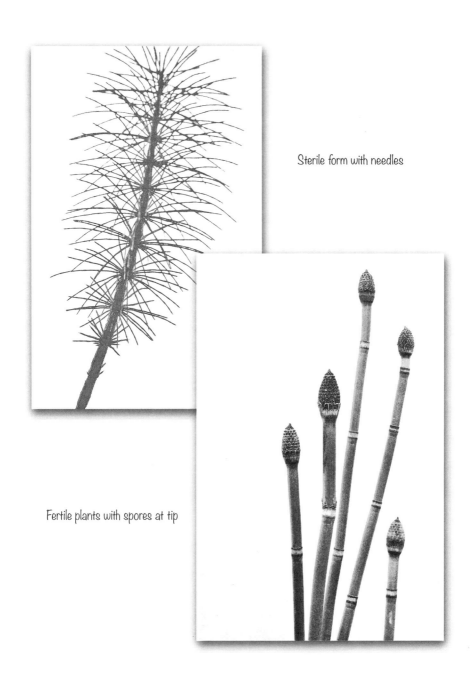

Sterile form with needles

Fertile plants with spores at tip

Common Horsetail
(*Equisetum arvense*)

17

Flowering Currant

A member of the Gooseberry Family, the Flowering Currant opens five petaled blooms in the months of March and April when its small flowers form pink hanging clusters. Hummingbirds, butterflies and native bees pollinate these flowers, turning them into tart blue-black berries in the summer. The berries are not quite as sweet as those of its close relative, the Canyon Gooseberry. Sweetness and storage duration can be increased by drying. Flowering Currant lacks Canyon Gooseberry's spines-an you suggest a reason for this? In other ways, these two members of the Ribes genus are similar, with medium sized, palmate leaves arranged alternately on opposite sides of stems. They both grows to a height of 1-2m in shaded woods and along streams.

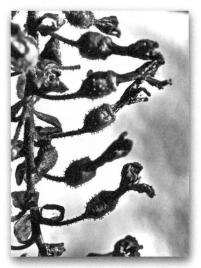

Once the flower is pollinated, the ovary starts to swell into a fruit.

Like many of the plants described in this book, Gooseberries and currants, have long been admired by gardeners. You can buy them and their cultivars (human selected varieties grown for garden characteristics) from nurseries specializing in native plants. They are valued for their brightly colored and scented flowers. Pleasing both in nature and in the garden, this plant's nectar feeds hummingbirds and a variety of butterflies, and its berries feed a large variety of birds and mammals. It requires little care other than some watering when planted and can be reproduced from cuttings- but never cut or pick plants protected in state or national parks.

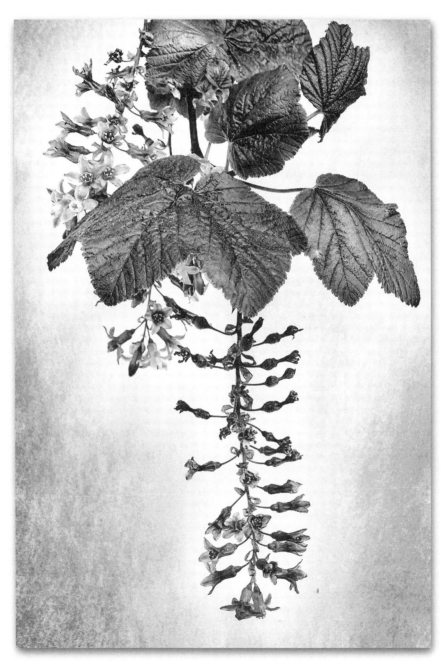

Flowering Currant
(*Ribes glutinosum*)

19

Canyon Gooseberry

This small shrub is decorated with delicate flowers hanging like Christmas tree ornaments. Its fruit and stems are covered with reddish spines, but interestingly, its small, palm shaped leaves are spineless. The Canyon Gooseberry's fushia-like flowers have white petals and red sepals and are pollinated by hummingbirds and native species of bees. It prefers semi-shady forests with moist, well drained soil, especially near streams and along trails. Its edible fruits contain about half the Vitamin C concentration of oranges.

In 1974, my Botany professor Dr. Sharsmith, as part of the course, assigned his students the project of making a plant collection. After grading mine, he asked if I would donate my specimen of this plant to the San Jose State herbarium (Duncan Hall, room 354).

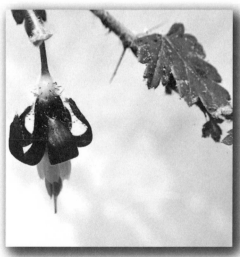
Sharp spines protect the flower.

I was honored, and agreed immediately. While writing this, forty years later, I realized that my deep interest in Botany dates back to that moment.

Upon going online, I discovered that the Herbarium has been renamed in Dr. Sharsmith's honor, and that it contains 14,685 specimens, of which mine is listed as Herbarium #7824 (see page 23).

After retirement, Dr. Sharsmith continued his duties as summer ranger at Yosemite National Park. At 90, he was the oldest in the Park system.

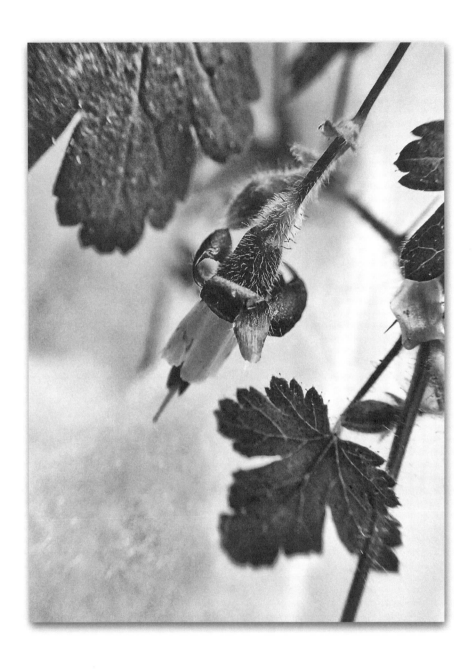

Canyon Gooseberry
Ribes menziesii

21

Carl W. Sharsmith Herbarium

Department of Biological Sciences
San José State University

Herbarium #7824

Group: Dicots

Scientific Name: Ribes menziesii Pursh

Synonym: Ribes Menziesii Pursh var senile (Cov.) Jeps.

Family: Grossulariaceae; Saxifragaceae 118

Tribe:

Country:

State: CA

County: Santa Cruz

Location: near Majors Cr c. 1000 m upstream from Smith Grade near Bonnie Doon

Habitat: in deep humus intermixed with granitic sand assoc with Sequoia sempervirens, Pseudotsuga Menziesii, & Ceanothus papillosus

Elevation: 902

Description: shrub 1.8 m tall, 1.5 m wide, the main stems 1-2 cm in diam at base

Other:

Collector: Casterson, D.B. 51

Date Collected: 4/30/74

Dr. Carl W. Sharsmith
Yosemite Research Library

2003 Tuolemne Meadows
Yosemite National Park

22

The Process of Speciation

A new <u>species</u> is formed by the accumulation of different traits over time. 'Mistakes' in the genetic code are called mutations and most of them are harmful to the individual that inherits them. Occaisionally they are neutral, or even more rarely, beneficial. Over time, traits that increase an individual's chances of reproduction are added to a population's gene pool. When enough new traits are added to an isolated population such that it cannot produce fertile offspring when crossed with other populations, a new species is formed. The process is known as <u>speciation</u> and occurs naturally as members of a population of plants (or animals, bacteria, fungi etc.) adapt to different habitats. Good examples of speciation are, Slim and Fat False Solomon Seal (pg. 24), Redwood and Two Eyed Violet (pg. 40), California Rhododendron and Azalea (pg. 88), Five Finger and Maidenhair Ferns (pg. 102), as well as Western Trillium and Giant Wake Robin (pg. 26).

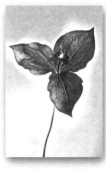

Western Trillium

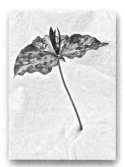

Giant Wake Robin

A phrase I used in my Biology classes to help students with the concept of speciation goes like this: "Reproductive isolation can result in speciation". If there is no reproductive isolation, either geographic (by water, space, mountains, etc), temporal (time of day, month or year a species reproduces), physical (size or shape etc.) or physiological (cellular incompatibility), a new <u>species</u> will never be produced. Instead, the species will change together, their genes moving in the same direction, like passengers on the same ship.

False Solomon's Seal

The two common <u>species</u> of False Solomon's seal provide practice in making careful observations and are a hands-on example of <u>speciation</u>. They are quite similar in appearance, with creeping underground stems (<u>rhizomes</u>), clasping leaves, and parallel leaf veins (characteristic of the <u>Monocotyledon</u> order of plants). They grow to a height of 30-50cm in the moist shade of the forest, bearing yellow flowers that form green berries striped with red. Leaves are the most variable part of a plant, and at first glance, you might think that one plant
has received slightly more light, water or nutrients than the other. But if you look
at a number of False Solomon's Seal plants, you will see that they are of two forms. The leaves of one <u>species</u> are more elongated and clasp the stem, while the other's tend to be more oval shaped and unclasping. The shapes of reproductive parts change very slowly over time, varying little from plant to plant. The flowers of Slim False Solomon's Seal (Maianthemum stellatum) are star shaped growing on a thin, zig zag stalk, while the flowers of Fat False Solomon's Seal (Maianthemum racemosum) are packed many to its straight stem.

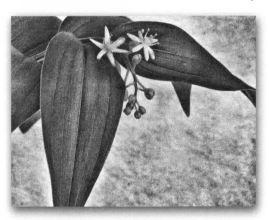
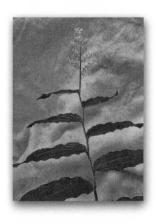

Without looking at the labels on the next page, can you identify these two?

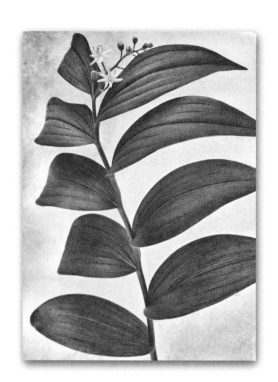

Slim False Solomon's Seal
Maianthemum stellatum

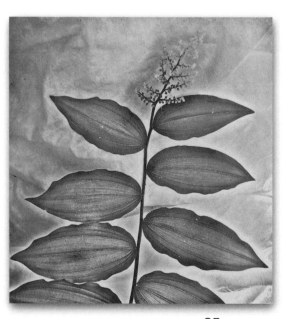

Fat False Solomon's Seal
Maianthemum racemosum

25

Western Trillium

Western Trillium was first collected for science by Meriwether Lewis along the rapids of the Columbia River during his famous Expedition of Discovery, the genus name, Trillium means 'in threes' in Latin: three leaves, three sepals and three petals. There are about 200 species of Trillium world wide. This one blooms March-May, forming single flowers white to pink to maroon in color on stalk and is pollinated by beetles, flies and bees. Its leaves are arranged in a whorl around the stem just below the flower. Western Trillium prefers shaded,

moist slopes in sight of the Coast Redwood. The closely related Giant Wake Robin grows in the northern section of the Coastal Redwood habitat. Giant Wake Robin is larger in size, as the common name suggests, but quite similar in shape. Its stalkless blooms are maroon in color, with a greenish tint, hence the species name chloropetalum which means green petaled.

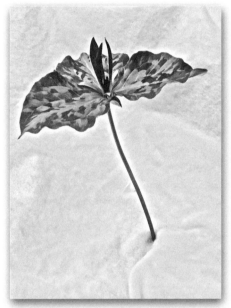

All parts of both plants can cause violent vomiting when eaten. Both elegant, long lived species sprout from rhizomes, and will come up year after year in the same place, enabling you to look forward to their 'arrival' each Spring. On the outer surface of the seeds of Trilliums--as well as violets, and wild ginger-- is a small, oily substance well described as an "ant snack". The ants collect this snack and feed it to their larvae, discarding the rest of the seed to germinate in the ants' chambers below ground.

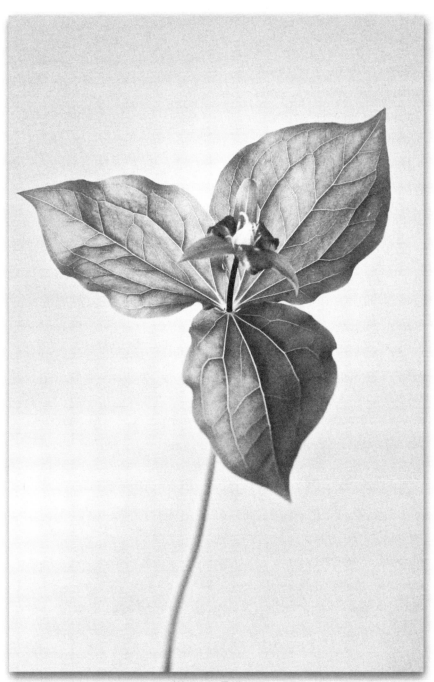

Western Trillium
(*Trillium ovatum*)

27

Miner's Lettuce

Well known for its 'salad greens' flavor, Miner's Lettuce, unlike true lettuces, remains tasty even when blooming. The flowers are <u>hermaphroditic</u>, that is, made up of male and female parts, as are most flowering plants. Miner's Lettuce is pollinated by flies. The tiny, white, five <u>petaled</u> flowers bloom February to May on a short stalk in the center of a disc-like leaf.

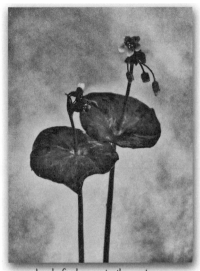
Look for leaves in the various stages of development

Initially, the leaves have long stems and are shaped like a snake's head. Later, the leaves unite into one, completely encircling the succulent stem in a parasol-like manner. The tiny flowers emerge from the middle of the parasol. Miner's Lettuce prefers moist, wooded areas, often along the edges of trails. I eat this plant often but haven't had the opportunity to place it near an ant hill as the <u>First People</u> did. Ants crawling over the leaves adds a vinegary flavor like salad dressing. All parts of the plant, including roots and flowers are edible raw. According to a study in the Journal of the American Dietetic Association, 100 grams of Miner's Lettuce, about the size of a decent salad, contains a third of the daily requirement of Vitamin C, and 22 percent of the Vitamin A. Eating the leaves helped miners during the Gold Rush avoid the effects of scurvy, a disease caused by a diet low in Vitamin C. It is also an important food for gophers, mourning doves, California quail, and other seed-eating birds. The seeds are just one mm in diameter and are easily spread. Under favorable conditions, Miner's Lettuce forms thick patches.

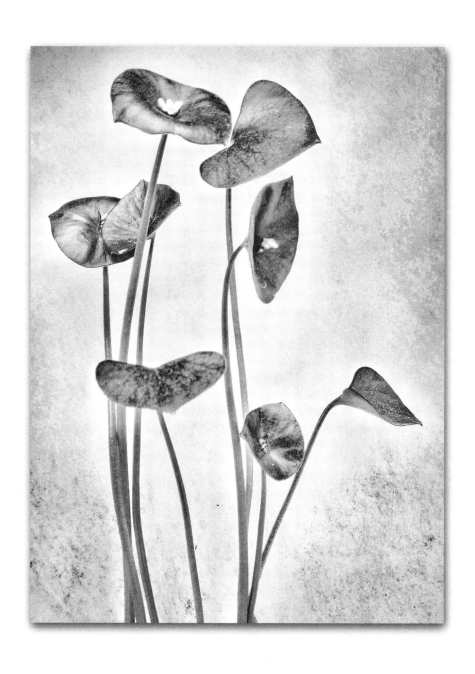

Miner's Lettuce
(*Montia perfoliata*)

29

California Polypody

This delightful fern produces a row of light cream colored spores in roundish clusters, a row on each side of its midrib in Jan-Apr. You will find California Polypody growing on moist rocks on cliffs and trail cuts as well as on trees. Its scientific and common names come from the Greek words poly meaning many and pod meaning foot, describing the many knobby branches of this fern's <u>rhizomes</u>. Like most ferns, it completely lacks flowers and fruit and is highly dependent upon moisture to transport sperm to eggs during fertilization. A typical fern, it is characterized by the production of great numbers of very tiny spores.

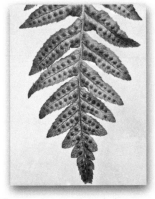

Sori can be seen through the pinna

Reproduction is an alternating, two generation affair, with separate spore plants producing a generation of plants that make sperm and egg cells (in a fashion similar to that used by mosses and liverworts). In the presence of moisture, sperms cells swim to fertilize egg cells which develop into a new sporophyte to complete and continue the cycle. Only the spore producing plant is recognized by most people as a fern. Ferns like California Polypody are most commonly found in moist, shady places. Sword (pg. 10) and Bracken (pg. 96) ferns are examples of a handful of ferns that have <u>evolved</u> ways to reproduce in drier habitats.

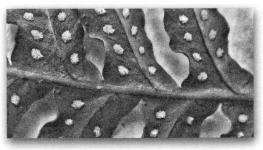

These sori are yellow at first then turn rust colored as they release their spores

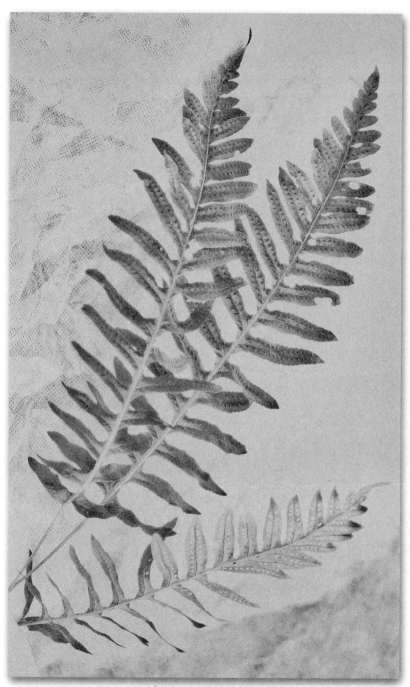

California Polypody
(*Polypodium californicum*)

31

California Bay

Related to cinnamon and avocado, the California Bay blooms Dec-Apr, producing attractive yellowish green flowers that profusely cover the tree. Yellowish green, smooth skinned fruits ripen in October; the <u>First People</u> roasted and ate them whole or ground into flour for bread. The fruit is also eaten by squirrels and Stellar Jays. The leaves are dark green, and finger shaped with a pungent scent. Mature trees have a thin, dark bark and grow to a height of 10-30m on wooded coastal slopes. I like to stick a leaf under the band of my hat so that the pleasant scent can distract me during a warm hike.

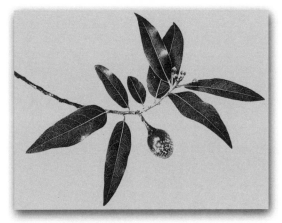

budding flowers and ripening fruit

The leaves can also find use as a spice for spaghetti and dried leaves can serve as an excellent fire starter (due to the presence of the oil which produces the pungent smell).

I discovered this one Fall, when, returning to my camp after dark, I realized that I hadn't brought fuel for my stove nor a flashlight. In the dark, my friend and I gathered some dried bay leaves and placed them in the fire ring. Upon striking a match, we were delighted by the bright flames that leapt from the burning leaves. Soon we had a fire going, were able to find food for dinner in our packs, cook it and sit back to enjoy our meal beside the campfire. Saved by nature again, I can only hope that my friend remembers my resourcefulness and not my forgetfulness!

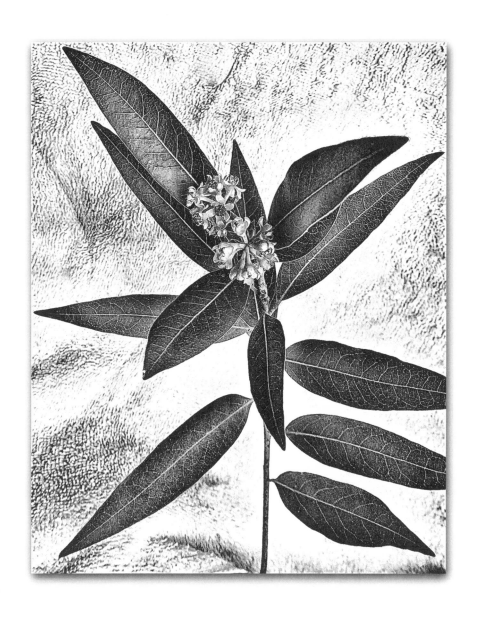

California Bay
(Umbellularia californica)

33

Grand Hound's Tongue

When you find Grand Hound's Tongue with its clusters of five petaled, electric blue-purple flowers, you have reached the midpoint of flower blooming in the Redwood habitat. Hound's Tongue's flowers mature to form a cluster of small nutlets with tiny hooks that catch easily in fur and clothing, aiding in its dispersal. This plant's large, rough, tongue-shaped leaves give rise to its common name. The leaves are mostly located around the base of the plant, each with an oval blade 15 cm or more in length.

These flowers may be pink as well as blue

Grand Hound's Tongue grows to a height of 30-60 cm, preferring the edges of the Redwood forest and along trails where soils are well drained. You will usually find it in shady spots, particularly on north slopes, either alone or in small discrete groups. It is a perennial, sprouting from the same taproot for a number of seasons, so that you can look forward to its arrival at the same location and time in subsequent years. Hound's Tongue leaves are reputedly toxic and, like most of the Borage family, contain carcinogenic chemicals called alkaloids, definitely making this a look-but-don't-eat kind of plant!

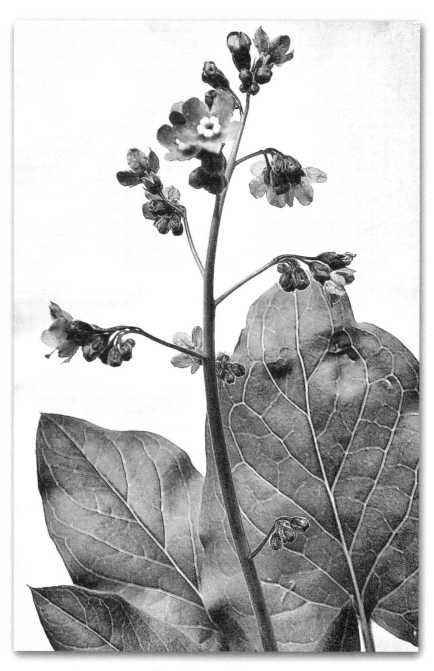

Grand Hound's Tongue
(Cynoglossum grande)

35

Giant Chain Fern

A fern that can grow taller than a person? Yes, its true! Also known by its <u>genus</u> name, Woodwardia, it is the largest fern in North America. Giant Chain Ferns grow in clumps with upright, arching <u>fronds</u>.

What is the clue to the presence of the spring behind this log?

Spore production takes place each Spring in rectangular <u>sori</u>, arranged in two parallel rows on either side of the midvein. The strong pattern of the <u>sori</u> can be seen on both sides of the leaf.

The Karok, Yurok and Tolowa tribes crafted baskets using fibers from this giant. The Giant Chain Fern prefers medium to deep shade, and is often found growing next to springs and seeps. This preference can be used to find sources of water when hiking.
Several years ago, a winter storm caused a small landslide on our road, depositing a clump of Woodwardia on the pavement. I picked up the homeless fern, and planted it

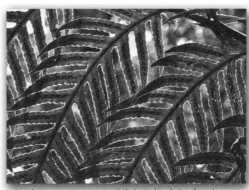

Look at sori pattern with light behind the fronds

along our front deck. In return for this favor, the fern responded in the Spring by spreading via <u>rhizomes,</u> forming a wonderful set of new <u>fronds</u>. Take a minute to turn one of its fern <u>fronds</u> toward the light. Then trace the pattern of the <u>sori</u> with your fingers, and bind yourself to it forever.

36

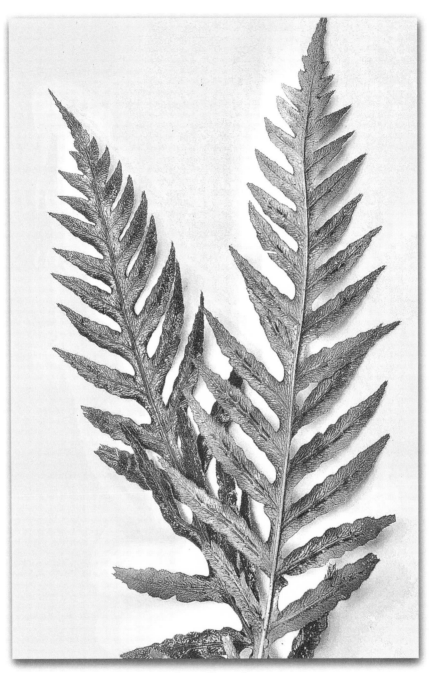

Giant Chain Fern
(*Woodwardia fimbriata*)

37

California Sweet Grass

This is perhaps the most common perennial grass growing in the company of Redwoods, preferring the semi shaded edges of trails. The lovely Sweet Grass

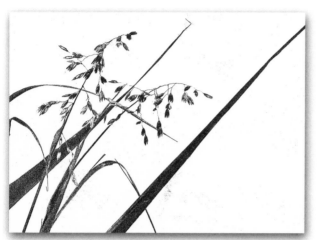

stands half a meter tall, with the parallel leaf veins typical of the Grass Family. The upper leaves are very distinct, standing stiffly erect.

Green flowers are a clue for wind pollination

Fresh leaves emit a sweet vanilla-like scent when rubbed between fingers, hence its other common name, Vanilla Grass. The fragrance is due to the presence of coumarin, which causes internal bleeding in cattle when when they eat too much of it. This observation lead to development of the drug Coumadin for the prevention of blood clots in humans. Interestingly, some First People tribes burned Sweet Grass for incense and the fresh leaves of related European species were used for fragrance in churches on Saints' Days. The graceful spikelets of Sweet Grass grow on wavy stalks, and produce seed via wind pollination (as do all grasses). Sweet Grass can also grow from bits of the elongated rhizomes. I have found that Sweet Grass to makes a nice mellow tea, and at that concentration, does not thin my blood appreciatively.

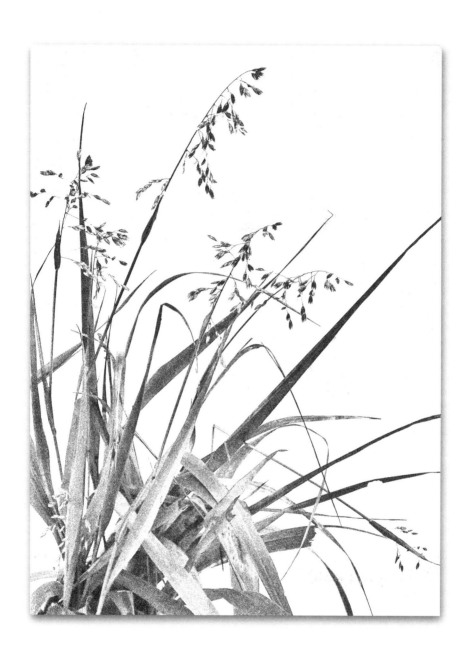

California Sweet Grass
(Anthoxanthum occidentale)

39

Redwood Violet

While the Violet Family contains the multi-colored garden pansy, most of the native _species_ are yellow to white. The Redwood Violet blooms Feb-June, producing five bright lemon yellow _petals_, the lower three of which have purple on them. They sit at the end of short reddish stems and are pollinated by butterflies. The leaves are evergreen and heart shaped, about the size of a quarter, with purple spots on the underneath sides. Redwood Violet is a very short plant, ranging 5-15 cm in height. Mature plants often produce new plants on above-ground runners.

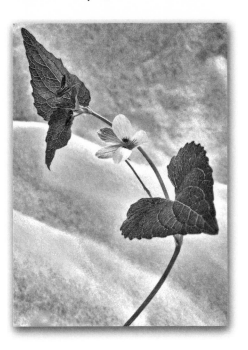

The Redwood Violet prefers the moist areas of the forest. This diminutive plant invites us to sit on the forest floor and admire the perfection of its flowers and leaves. It shares its _species_ name, (sempervirens, meaning evergreen) and habitat with the worlds tallest plant, the Coast Redwood.
If you are sitting next to a Redwood Violet, look upwards and you will probably see a tall Redwood growing nearby.

Two Eyed Violet
(_Viola ocelata_)

This white-_petaled_ close relative to the Redwood Violet is found in similar habitats.
What differences are there between these two species?

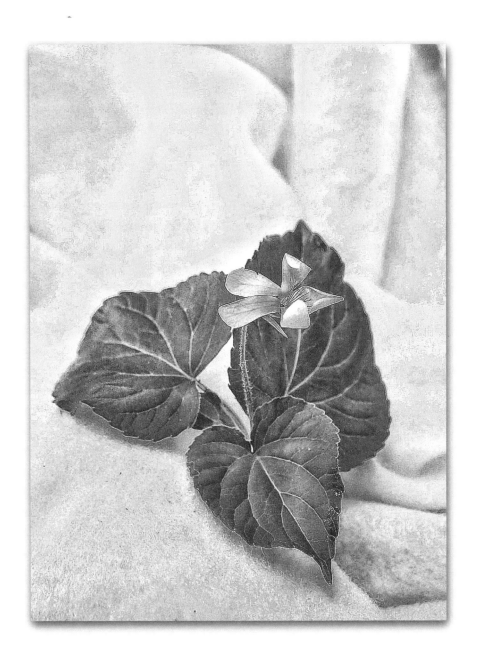

Redwood violet
(*Viola sempervirens*)

Wood Strawberry

If you have ever grown these berries, you will immediately recognize its distinctive leaves. Growing in groups of threes on long thin stems, the edges of the leaflets are strongly toothed and sharply veined. The Wood Strawberry has white flowers with five <u>petals</u> arranged around a bundle of short yellow <u>pistils</u> and <u>stamens</u>. Its <u>sepals</u> point backwards. The Wood Strawberry (or Woodland, as it is also known) is a member of the Rose Family which includes herbs, shrubs, and trees. There are about 100 genera and 3,000 <u>species</u> in this worldwide family which includes apples, pears, cherries, plums, peaches, apricots, blackberries, raspberries and other important fruits.

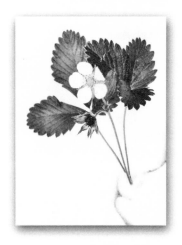

How would you describe strawberry leaves?

When the flower is pollinated by insects, the Wood Strawberry's small red fruits form singly on the thin flower stalks. They are higher in nutritional value and with a more concentrated taste than commercially grown strawberries. Like with most berries, the tiny seeds are dispersed by birds. The Wood Strawberry can also reproduce non-sexually (new plants are exact clones of parent), growing from runners which form roots of their own and separate from the parent. The Wood Strawberry is most often found in shaded woods or near streams.

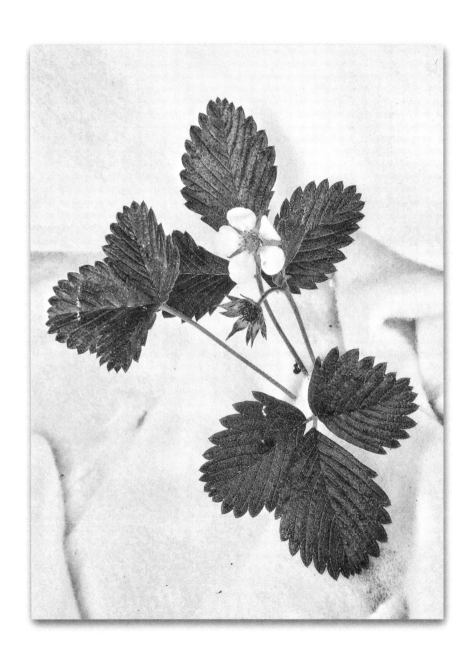

Wood Strawberry
(Fragaria vesca)

43

Redwood Sorrel

Forming large 'enchanted carpets' on the damp, shaded forest floor beneath, this plant is the one that first comes to mind when one thinks of plants that thrive in the company of Redwoods. Its genus name is Latin for 'acid juice', due to its sour taste. Chewing on a leaf or stem may remind you of the taste of the closely related 'sour grass' (Oxalis pes-caprae) a common invasive weed with bright yellow flowers, a native of South Africa.

Redwood Sorrel blooms from Feb-Aug, bearing single, bee pollinated five petaled white flowers, which turn to pink with age. Despite its clover-like leaves, it is not related to true clovers. This is an example of what biologist call convergent evolution, where adaptive changes in two unrelated groups arrive, over time, at a similar design. Sharks and dolphins, are animal examples of this kind of evolution. Redwood Sorrel's leaves are able to photosynthesize at low light levels (1/200th of full sunlight). They are also very sensitive to water loss, and fold their leaves down, like a collapsed umbrella, to conserve water under the sun's heat. When shade arrives again, they unfold their leaves once more. The movement is observable to the patient eye. While you hand tint the picture on the next page, you can test this for yourself by shading a Redwood Sorrel plant that has been in the sun.

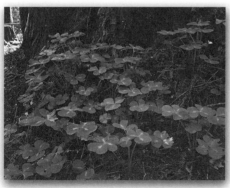

Redwood Sorrel carpet beneath Coast Redwoods

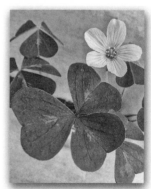

You may find it blooming for over six months of the year

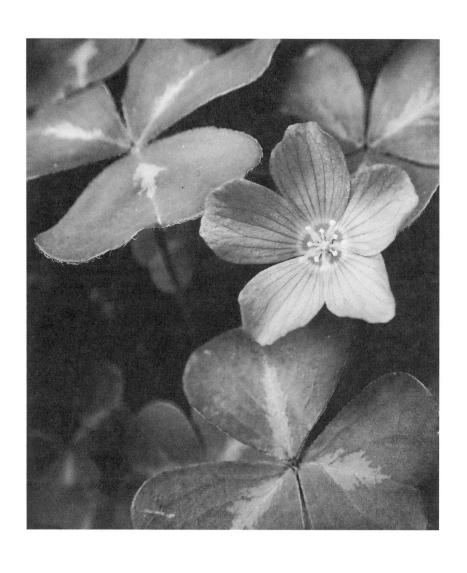

Redwood Sorrel
(*Oxalis oregana*)

Goldback Fern

The small, highly divided triangular <u>fronds</u> with thin bright black stems make this one of the more interesting ferns. The black stems reveal its relationship to the other Brake Family Ferns, the Maidenhair and Five Finger ferns. It is found as a solitary plant as well as in small colonies.

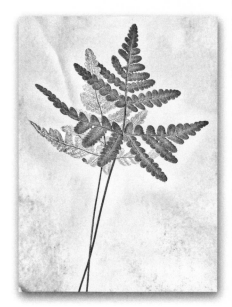

How would you tell if the spores were mature?

The Goldback fern measures 5-15 cm in height, growing on shaded old road cuts and rock outcroppings in Redwood forests. It is a very hardy little fern, able to withstand long periods of dryness and is found at elevations ranging from 0-2500m throughout California. The Goldback fern's waxy white spores turn golden when mature and are easily released by touching the undersides of <u>fronds</u>. Pressing the underside of the leaf against your skin, or a piece of dark clothing, will leave a decorative pattern, delighting you, as it has generations of Yurok Tribe children. The <u>First People</u> also used the Goldback fern as an analgesic for toothache and for women after childbirth. The <u>fronds</u> of the Goldback grow much like other fern <u>species</u>, first appearing as small fiddle-heads, which then unfurl to grow into full-sized triangular <u>fronds</u> as described by their <u>species</u> name. With the coming of Summer, the edges of the Goldback Fern's <u>pinnae</u> curl, decreasing the <u>frond</u>'s surface area, thus reducing water loss during warmer and drier weather.

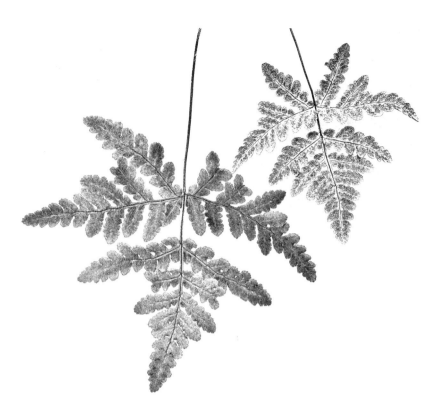

top side (left) underneath side (right)

Goldback Fern
(Pentagramma triangularis)

Wild Cucumber

As its name suggests, Wild Cucumber is a member of the Gourd Family, which includes a multitude of New World plants now used by humans throughout our planet, including zucchini, pumpkin, and squash. Wild Cucumber blooms March-May on delightfully elongated vines. One species (Marah fabaceus), inhabits the southern range of this plant and has greenish-cream, cup shaped flowers, while another closely related species, (Marah oreganus) grows in the more northern range and has a white, bell shaped flower. Both species have five pointed leaves the size and shape of ivy leaves, and use their tendrils to grab hold, enabling their climbing vines to cover nearby shrubs and small trees. In medium shade, Wild Cucumber forms male flowers growing in a branching, drawn-out cluster (known to botanists as a raceme), while the female flowers grow separately. The roots are huge, vaguely resembling the shape of a human, hence its second common name, Manroot.

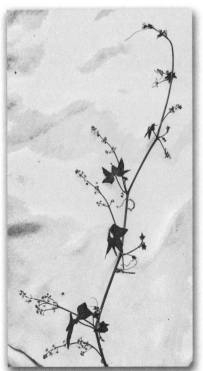

Can you tell the male and female flowers apart on the next page? Hint: Find the spine covered gourd starting to form.

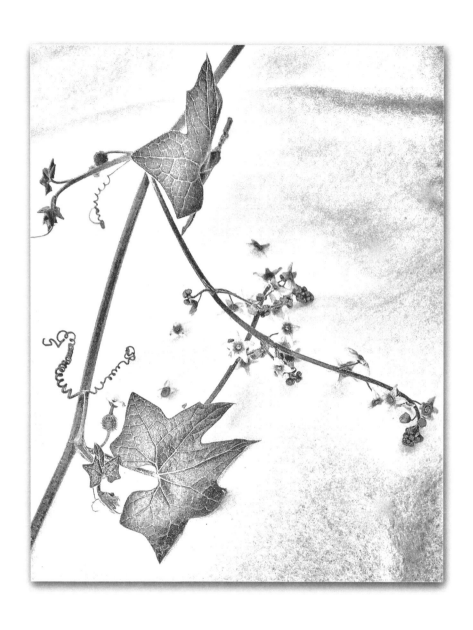

Wild Cucumber, Manroot
(Marah fabaceus)

Madrone

This member of the Heath Family grows along the Pacific Coast from Southern California all the way up into British Columbia, Canada, where the name Madrona is used. One cannot help but feel a certain kinship with the Madrone and there is much to be drawn to: the flowers, the berries, the bark and its sensuously twisted limbs. From March-May the Madrone bears white bell shaped flowers in showy, sweetly scented clusters pollinated by bees. Madrones produce edible red berries, which ripen for the winter holidays.

Madrone bears glossy leaves all year round and is relished by insects, as you can tell from their chewed appearance. The thin, scaly bark on all but the oldest parts of the tree peels away in early Summer, exposing a smooth pale green wood that soon changes to deep orange-red. Few can resist touching its human-like limbs. It grows to a height of 7-30m beside Douglas Fir and Tan Oaks, forming a beautiful mixed evergreen forest.

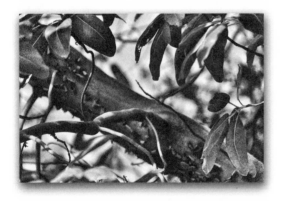

Madrone's bark peels away, exposing smooth limbs

A pleasant tea can be made by pouring boiling water over bark peels from a Madrone. The resulting cinnamon colored tea is mellow with a fragrance of smooth wood and blends well with cinnamon or honey. Perhaps you will be lucky enough to share a warm cup with a friend, sitting next to a large Madrone, working with your colored pencils on a Fall day.

50

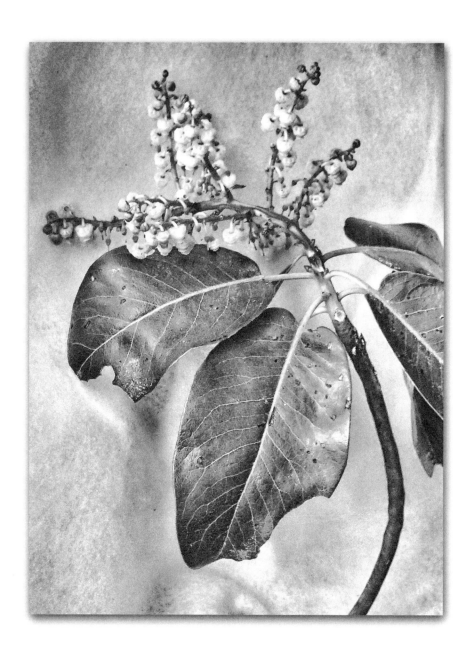

Madrone
(*Arbutus menziesii*)

California Huckleberry

California Huckleberry is a woody evergreen <u>perennial</u> Pacific Coast shrub with thick, leathery leaves which grows to a height of 1-2m. Like Poison Oak, this plant is highly variable in its choice of habitat. California Huckleberry is common as an understory plant in Redwood forests, but is also found as part of the Chaparral Community, where it is shorter but with sweeter berries due to increased sun and heat. Rumor has it that Mark Twain so liked pies and jams made from the berries of this plant that he named his famous character, Huckleberry Finn, after it. The California Huckleberry is one of the four Heath

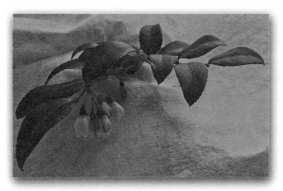

Huckleberries often sprout atop Redwood stumps

Family members in this book. Only the Rose Family, with five examples, is better represented in the Redwood habitat. California Huckleberry blooms Mar-June, producing clusters of small, bell-shaped pinkish white flowers. Pollinated by bees, these flowers form ten-seeded black-blue berries that ripen August-October.

Varieties of this plant have been selected to be commercially grown. Preferred habitat is in low elevation forests with well drained, humus-rich soils, especially at edges and canopy openings. Tolerant of shade, its active growth period is spring and summer.

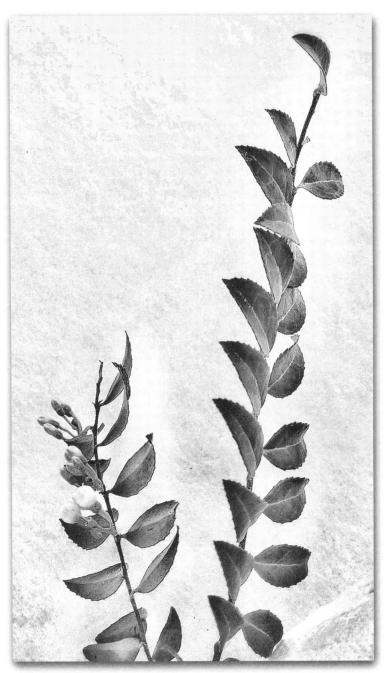

California Huckleberry
(*Vaccinium ovatum*)

53

Salmonberry

This extremely attractive plant with its delicate trailing foliage bears plump, yellow and red berries which seldom remain long on the vine. Salmonberry can form dense 1-3 m tall thickets, with reddish-brown canes covered with short prickles. The leaves are composed of three velvety leaflets and the showy flowers are pollinated by hummingbirds, bees and other insects. Salmonberry reproduces from seeds distributed by birds, from <u>rhizomes</u> and from creeping above-ground stems.

Salmonberry grows back quickly from its root crowns when damaged by cutting or fire. Its seed is able to sprout after many years and also germinates well after a fire, or on soils disturbed by logging. Salmonberry is considered a <u>pioneer species</u> because it is one of the first to recolonize disturbed areas. Its deep root system helps prevent soil erosion.

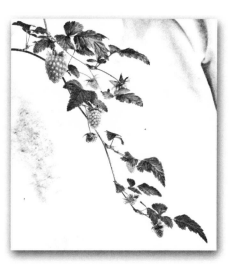

Salmonberry provides food and cover for a wide variety of birds and mammals. Elk forage on its

Can you draw a food web starting with this plant? There is an example on page 108

twigs and leaves as do deer, bear, rabbits, porcupine and beaver. Its fruit is eaten by coyote, bear, opossum, squirrels, raccoons, quail, band-tailed pigeons and various thrushes, and the seeds provide food for mice. Easy to grow, Salmonberry was first cultivated in the 1800's for its beauty and berries, which make a fine jelly.

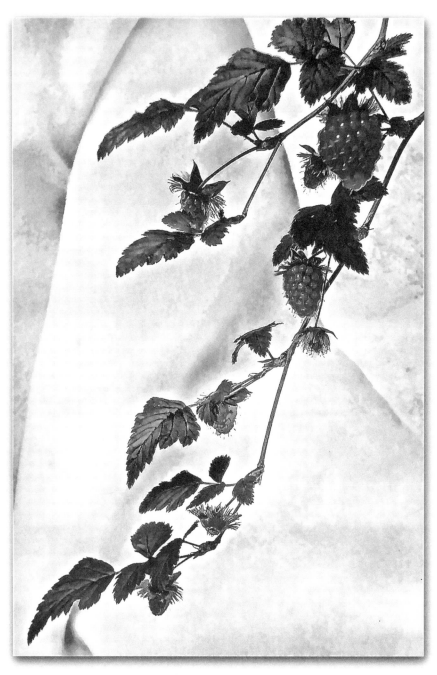

Salmonberry
(*Rubus spectablis*)

55

Douglas Iris

David Douglas (1799-1835), a fearless botanist who roamed the Pacific Northwest, described the Douglas Iris in 1830 from plants he collected near Monterey. Its stunningly blue-violet blooms caught his eye, as they will yours! Pollinated by Bumble and Carpenter bees, the three-petalled flowers and parallel veined leaves are clues to its monocot heritage.

The leaves are shiny green above, and dull green below. Douglas Iris prefers grassland on the coast and shaded Redwood forest inland. As beautiful as this iris is, remember that ALL PARTS are POISONOUS.

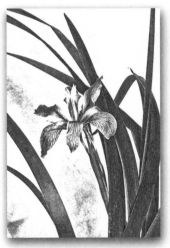

What colors besides blue have you seen in this bloom?

Douglas Iris often form large perennial groups. These clumps are commonly made up of clones; and may live to be hundreds of years old. A vigorously growing plant, Douglas Iris readily hybridizes with each of the other Pacific Coast native irises where their ranges overlap. When Douglas Iris is found farther inland, it usually has crossed with other iris species better adapted to less exposed, shady habitats.

Long established natural hybrid populations have been given their own names, like "Marin Iris" and "Santa Cruz Iris" in the Coastal Range, just north and south of San Francisco's Golden Gate. Many of the irises in nurseries around the world are a result of hybrids humans have made using the Douglas Iris.

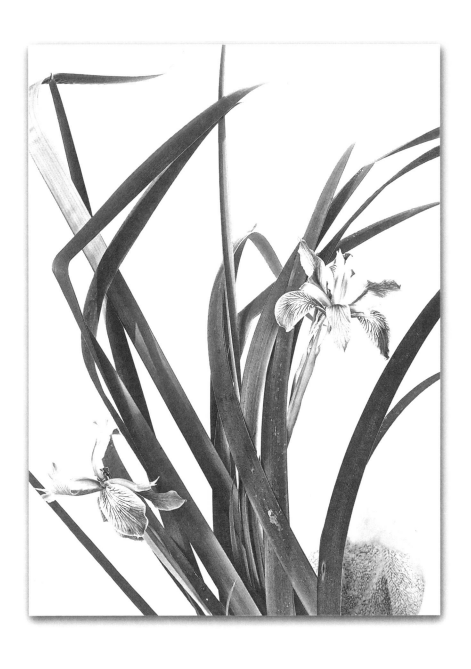

Douglas Iris
Iris douglasiana

Big Leaf Maple

The Big Leaf Maple is the largest of the five native California Maples. It is deciduous and blooms just as the tree is leafing out. The bloom is a yellowish green, and forms long, drooping clusters of bell shaped flowers which are pollinated by bees. The Big Leaf Maple's pale green leaves are hand shaped (classically palmate) and turn yellow to orange in the Fall. That is when the seed clusters mature, releasing hairy, single winged, whirling 'helicopters' (see next page) which spin their way down to earth, aiding in seed dispersal. The bark of young trees is a smooth light gray, but turns a darker gray-brown and cracks with age.

The Big Leaf Maple grows to most of its potential height (15-30 m) within 50-70 years, and some individual Big Leaf Maples may reach 300 years of age. This fine tree is native to western North America, most common near the Pacific coast, from Alaska to southern California, growing along streams and in moist areas throughout the Redwood ecosystem. Succession refers to a sequenced change in the 'cast of characters' following environmental devastations like fire and flooding. Following willow and alder, Big Leaf Maple populations increase during the mid to late stages of riparian succession. The foliage and young stems of Big Leaf Maple are preferred by elk and deer, while birds, squirrels and rodents feed on the seeds.

pre-bloom stage (above), mature Maple seeds (right)

While you sit reading and hand tinting beneath your Big Leaf Maple, consider how it contributes to the lives of those who live in the forest and also to the lives of humans. 100 mature maple trees are required to absorb the amount of carbon dioxide the average U.S. citizen adds to the atmosphere each year. We need their help (and the help of all plants growing on land and the algae growing in rivers, lake and oceans) to balance our carbon account. Take care how much carbon spending you do... 58

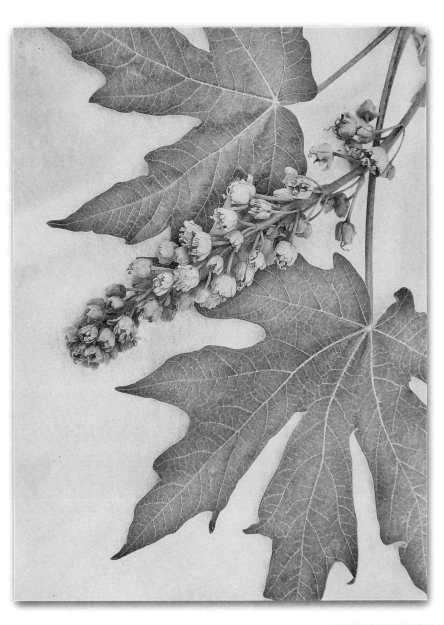

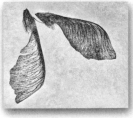

Big Leaf Maple
(*Acer macrophyllum*)

Red Clintonia

Also known as **blue bead lily and Andrew's** Clintonia, this amazing California native blooms April-June, bearing twenty or more pink, trumpet shaped flowers at the top of a nearly leafless stalk. Each flower has six pink petals (a multiple of three, following the Lily family flower plan). After pollination by hummingbirds, bright Prussian blue colored reportably toxic berries are formed that ripen in the Fall.

Red Clintonia keeps close company with Redwoods, growing under their shade in the moist soil of the coastal fog belt. If you look carefully, you may find Trillium growing nearby, almost as if the two are best friends.

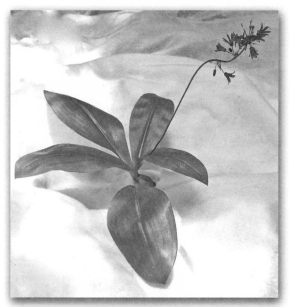
What other plants have leaves like Clintonia?

Around the base of the plant are five or six large wide, shiny, oval-shaped green leaves. Red Clintonia leaves stay green throughout the dry summer. It is capable of both self and insect pollination, and sometimes sprouts from the slender rhizomes. It is quite a joy to revisit the site where you found this plant in previous years and find it standing straight up with its lovely bloom- a welcoming beauty in the shaded Redwood forest.

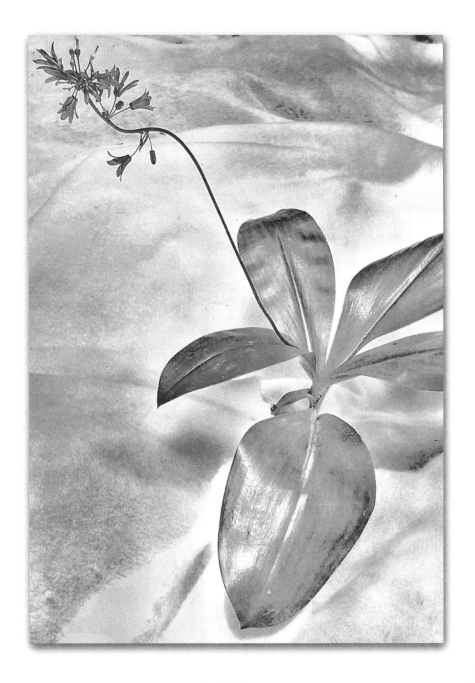

Red Clintonia
(*Clintonia andrewsiana*)

61

California Blackberry

California Blackberry grows rapidly, producing small, white flowers that are pollinated by wild bees. Typical of the Rose Family, it bears 5 <u>petals</u> surrounding a cluster of anthers, similar to the flowers of Thimbleberry.

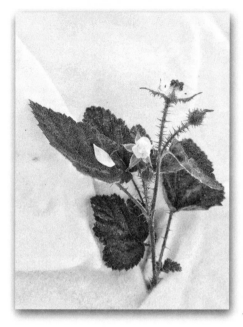

What is your favorite relative of this plant?

Blackberries flower and fruit on year-old bud wood as opposed to new wood or spent canes. The California Blackberry flowers in March and April, producing small flavorful blackberries by late May and June. Don't eat the red ones - they are tart and sour. The berries turn a deep dark purple, or black when ripe and ready to eat. The prickles are tiny compared to its non-native relative, the Himalayan Blackberry (which has larger and juicier berries), but you still need to be cautious when picking these tasty delights. The wild California Blackberry was used to develop the commercially grown Loganberry, Boysenberry, Marionberry and Youngberry. Botanists describe California Blackberry leaves as <u>compound</u>, being that they are made up of leaflets, in this case, three. Because they turn red in late summer, the leaves vaguely resemble those of poison oak. The fact that, unlike poison oak, they are pointed and the stems are lined with thin prickles makes them easy to differentiate. California Blackberry prefers sunny areas near water, especially along trails. The <u>species</u> name ursinus means bear, a reference to the Black Bear's preference for them. They also provide food for hummingbirds, quail, rodents and bees.

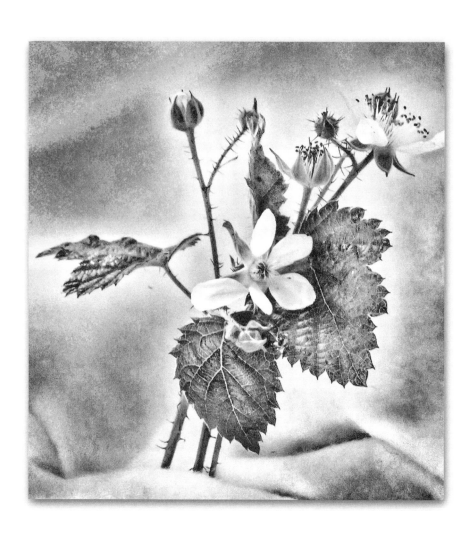

California Blackberry
(*Rubus ursinus*)

Thimbleberry

When you see its five brilliant white petals surrounding the flower's center where a single thimble cap-shaped berry forms, you know at once its Family and relatives. Blooming Mar-Aug, Thimbleberries are pollinated by native species of bees. They ripen mid June to mid July, closely resembling the domestic raspberry, but without the thorns. The hollow red fruit is tasty raw, dried or cooked into pies. Thimbleberry is one of the sweetest native berries, but requires patience-- don't pick them when pink, but wait for a deep red color to appear. The large, palmate leaves are covered with soft, wooly hairs that, like kleenex tissue, can be used for cleanup.

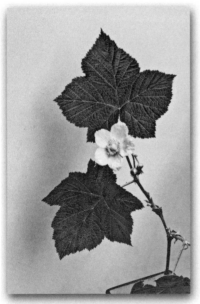

What adaptations does this plant have for regrowth after a fire?

Thimbleberry grows in moist shaded forests. There are about 100 tiny seeds in each berry and they are easily dispersed by mammals and birds, especially crows and thrushes. Thimbleberry seed in the soil seed bank can sprout years after the parent plants are gone. Like Salmonberry, as a pioneer species, it repopulates soon after burning, logging and other disturbances, beginning the process of succession. In this way, nature returns the wounded habitat to a long term, sustainable state. The Thimbleberry is fun to grow as its stems are easily rooted in moist soil. In a year or two, in conditions that match those it chooses in nature, the new plant will give back to you very attractive leaves, flowers and fruit.

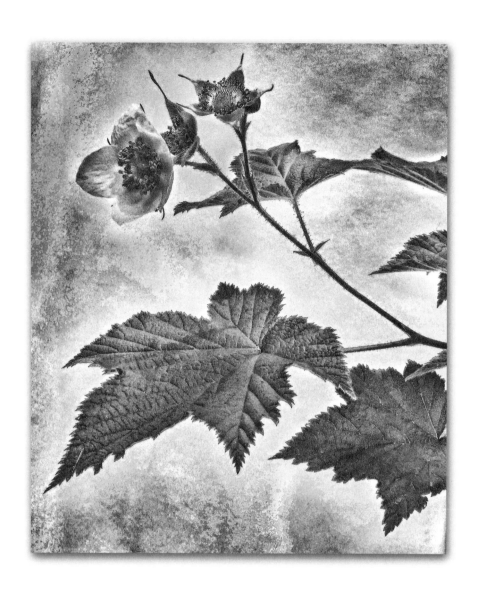

Thimbleberry
(*Rubus parviflorus*

Wild Ginger

Wild Ginger belongs to the Birthwort Family, which gets its name from its use in childbirth. The maroon blooms appear March-June, but are often hidden in its foliage. Wild Ginger's distinctive three long-tailed <u>petals</u> remind me of the playful nature of a court jester's hat. The heart-shaped leaves, slender stems and <u>rhizomes</u> creep along the forest floor giving off an aromatic spice-like scent. Wild Ginger has been used for the ginger flavoring of candy.

Wild Ginger grows under the Redwood's dense shade in acidic soil. Wild Ginger is a <u>hermaphrodite</u>, and thus able to reproduce through self <u>pollination</u>. It can also sprout (more energy efficiently) from its <u>rhizomes</u>. Like Miner's Lettuce, a small appendage on Wild Ginger seeds is rich in an ant-attracting oil and ants regularly carry the seed to their nests, feed on the seed appendages, and discard the seed in piles, effectively dispersing the seed to form new plants.

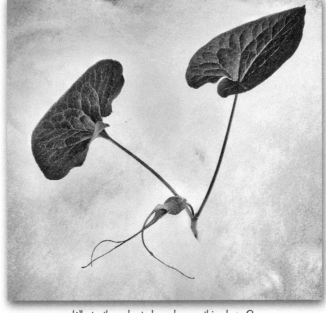

What other plants have leaves this shape?

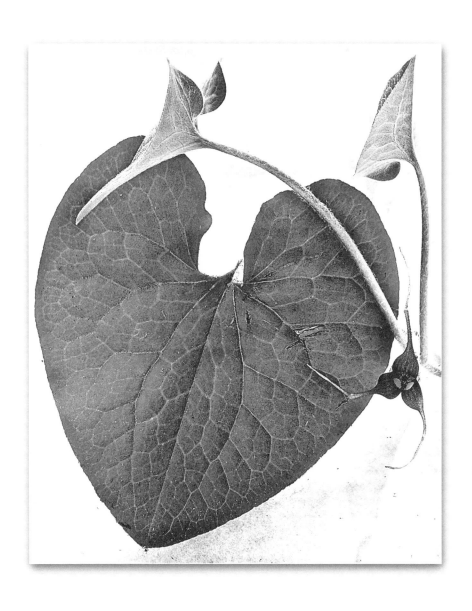

Wild Ginger
(*Asarum caudatum*)

67

Brook Foam

I love to spend time along streams, and Brook Foam loves to grow on rocks alongside the splash of a lively brook, which make us the best of friends! Brook Foam's tiny white flowers, made like fine jewelry, sit in an open array atop long, graceful stems. Some attribute its <u>genus</u> name to the Latin word meaning 'Rock Splitter', a reference to an old belief that it was useful in splitting kidney stones. I like to think instead, that 'Rock Splitter' is a way to describe Brook Foam's ability to grow in the cracks of rocks along a creek, requiring little soil to grow. The fine hairs on its leaves appear to be an adaptation for conserving water through reducing evaporation.

Brook Foam is commonly found in large numbers on rocky and moist overhangs from California to British Columbia. A number of similar looking members of the Saxifrage family can be found in the Redwood habitat, including California Saxifrage, Sugar Scoop and FringeCups. Most saxifrages are smallish, bee pollinated plants, whose leaves grow close to the ground and ring the stem in an arrangement botanists poetically call a <u>rosette</u>.

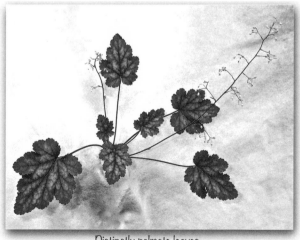

Distinctly <u>palmate</u> leaves

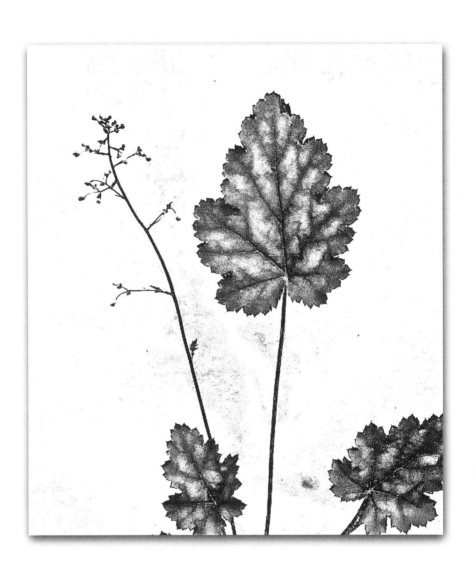

Brook Foam
(*Boykinia occidentalis*)

Douglas Fir

Reaching up to 70m, the Douglas Fir is second in height only to the Redwood in California. Pseudotsuga is Latin for "false fir", explaining why Douglas Fir is placed in a different genus than the true firs. Like all conifers, it is wind pollinated. Female seed producing cones form Apr-May on the high branches, with male pollen producing cones forming on the low ones. Cones ripen mid summer and open in Sept, shedding vast quantities of germinating seeds before falling from the tree.

If you live in the western U.S., wood from Douglas Fir trees probably supports your walls.

The Douglas Fir has grown on the slopes of mixed evergreen forest since the mid-Pleistocene era, some one and a half million years. The flattened green needles contain Vitamin C and chewing gently releases a pleasant, almost minty taste. Many enjoy the aroma of the tea made from its needles. The current year's growth is light green, easy to distinguish from last year's growth, giving clues about the favorability of the current year's weather as well as the tree's relative health.

Adult Douglas Fir trees are widely used to build houses and young trees are often sold as Christmas trees. When our the kids were small, I would transplant young 'Doug Fir' seedlings from crowded, sun-starved spots in the forest behind our house to places along the edge of our orchard. After a few years, we would cut and bring them inside to decorate. If I take a thermos of 'Doug fir' tea out there, the scent of days past rolls over me, like the fog that these trees need to thrive...

70

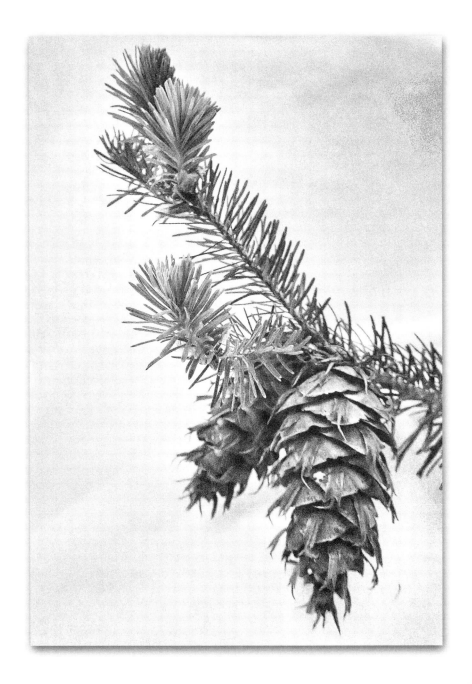

Douglas Fir
(*Pseudotsuga menziesii*)

71

Pacific Starflower

The diminutive Pacific Starflower blooms March-June on the end of impossibly thin stems. Its pale pink pointed petals form one to four flowers which seemingly float like stars above green leaves. Interestingly, unlike most flowers, the number of petals routinely varies from five to seven. Pacific Starflower is a perennial, living three or more years. Unlike many wildflowers, its small black seeds do not remain viable in the soil for more than a few seasons. To the Pacific Starflower, asexual reproduction by tubers is more important than reproduction by seeds. Three to six broad elliptic leaves are arranged in a whorl on a stem. Despite its lack of height, under the proper growing conditions, this delicate flower can outcompete all others for a moist, shaded space on the forest floor. The genus name, 'Trientalis', is derived from the Latin for 1/3 foot, which is the approximate height of these plants, and 'latifolia' is from the Latin 'latus' (wide) + 'folium' (leaf).

The First People collected and ate the tubers, but for me, its delicate beauty is enough...

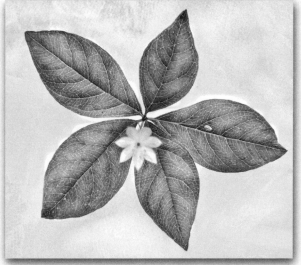

How does this Starflower differ from the one one the next page?

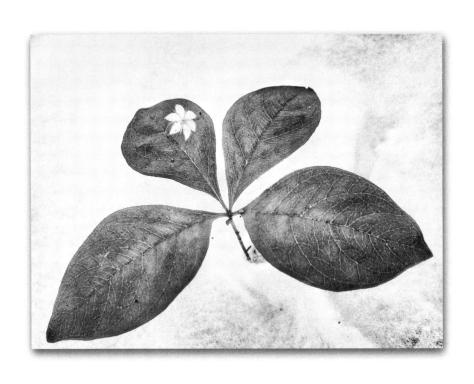

Pacific Starflower
(*Trientalis latifolia*)

Poison Oak

Poison Oak is a pretty plant, especially in the Fall when the leaves turn a fiery red. Unlike most plants, botanists describe it as <u>dioecious</u> for the male and female flowers grow on separate plants. All Poison Oak leaves have three leaflets, but the plants have two forms; small shrubs AND vines that climb high into trees. Poison Oak also varies in its habitat from moist Redwood forest to dry chaparral. Learn what it looks like in all forms and locations! ALL parts of Poison Oak (leaves, roots, stems, flowers and berries) contain the skin-irritating oil urushiol (<u>genus</u> name: toxic) causing rash and swelling, in some cases requiring hospitalization. Each year, hundreds of California fire fighters are so severely affected that they are unable to work. Avoid touching any part of Poison Oak, breathing the smoke of it burning, touching clothing or a pet that has brushed against the plant (or been exposed to its smoke).

Only one in six people are immune to urushiol as I am. Once, when my wife developed a hand-shaped skin rash on her leg, I was deemed the source as my hand matched the rash, finger for finger. The First People were largely unaffected by the poison and used the milky sap as a dye in baskets and tattoos. When leafless, Poison Oak's smooth light brown stems must be identified by shape and color. I know of many people who have reduced their susceptibility to poison oak by eating tiny

Poison Oak berries. Don't eat!

pieces each Spring. They place a tiny bit directly into the mouth, chew carefully and lick the urushiol oil completely off their fingers, repeating with a slightly larger piece each week for a month afterwards. This works great for some, but I'm <u>NOT</u> suggesting that you try it!

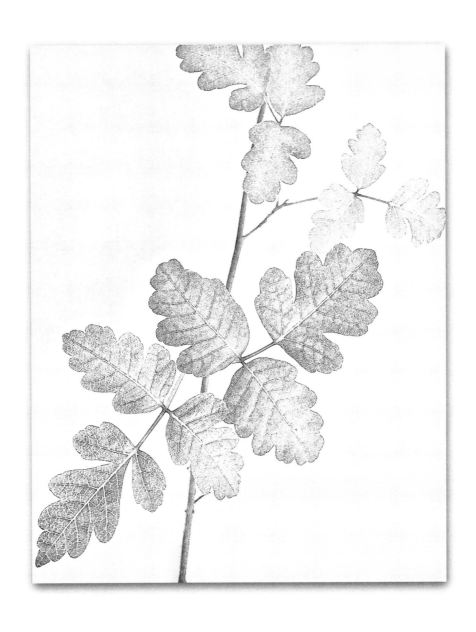

Poison Oak
(*Toxicodendron diversilobum*)

75

Vanilla Leaf

When you first see Vanilla Leaf, you feel that you have somehow entered the world of fairies. It spreads to form lush and lovely carpets of bright green in the deep shade of the Redwoods. Vanilla Leaf, bearing two delicate spikes, emerges in March. The larger of the two spikes is adorned with white flowers Apr-June. The flowers are unusual in that they lack sepals and petals. The genus name is Greek meaning 'thin mist' referring to its inconspicuous flowers, and the species name means 'three leaves'. The leaf is distinctive with its large, three part 'lily pad' shape and sweet vanilla scent.

Vanilla Leaf was used by both the First People and pioneers to make sachets to perfume their houses. You might collect some to try for yourself when you find some growing outside the boundaries of a preserved area. Vanilla Leaf grows along the west coast, from northern California to British Columbia.

When dried properly, the plants are strongly aromatic and smell of vanilla. Besides serving as an excellent tent air freshener, Vanilla Leaf was used by native tribes of southern British Columbia as an insect repellant. The dried leaves were hung in bunches in doorways to ward off flies and mosquitoes. Some naturalists rub the leaves on exposed skin when hiking during the summer mosquito season.

What use does a lily pad shaped leaf serve in Redwood forest?

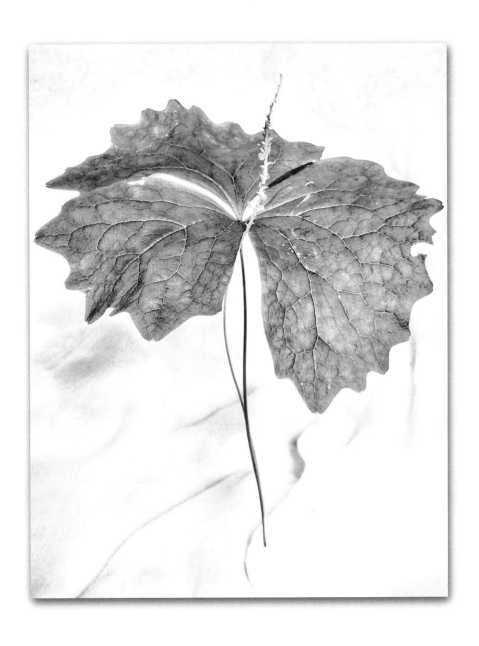

Vanilla Leaf
(*Achlys triphylla*)

77

Cow Parsnip

The largest species of the Carrot family in North America, Cow Parsnip grows to a height of 2.5m in wetland areas. It is a biennial or two-year plant, producing seeds the second year. Typical of this family, its white flowers are arranged in umbrella like formations and pollinated by bees. Their hollow stalks are swollen where they enclose the base of leaf stems. Also sometimes swollen to tennis ball size are the tops of the stems, which are really just huge flower buds waiting to emerge. Their leaves alternate (right-left-right-left) along its stalk, and are made up of three leaflets. Individual leaves measure a

massive 10-30 cm wide. As you can see, with the exception of the individual flowers themselves, everything seems to be on a rather large scale, befitting its scientific name, Heracleum maximum, coming from the the Latin for Hercules.

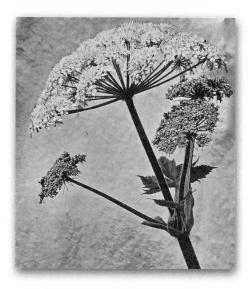

Early in each year, the First People peeled and ate the young sweet, aromatic leaf and flower stalks. They also used Cow Parsnip as an insect repellant by

How would you expect the flowers of

rubbing its strong-smelling flowers and leaves upon their skin. Cow Parsnip prefers very moist, partially shaded habitat. It is host to the caterpillars of Anise swallowtail butterfly and attracts numerous other insects and birds as well.

78

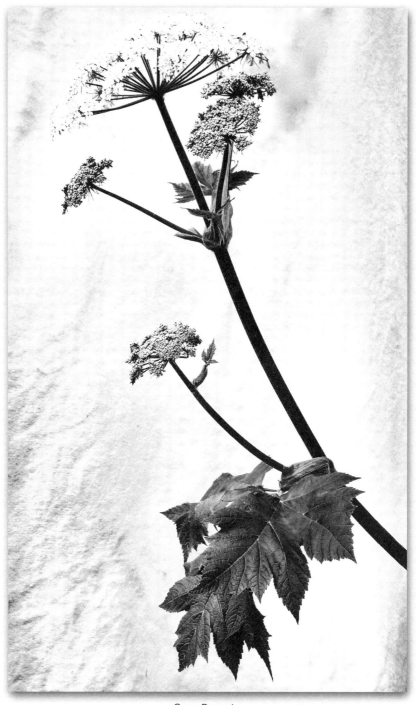

Cow Parsnip
(*Heracleum maximum*)

79

Salal

The scientific <u>species</u> name 'shallon' comes from Meriwether Lewis' name for the plant when he encountered it on the Corps of Discovery expedition in 1805. Its pink, urn-shaped flowers bloom Apr-June. Their stems bend as they develop, so in time, they suspend the flowers straight down. In late summer, pollinated by bees and flies, the flowers form five to ten dark purple fruits, each containing many seeds.

The abundant fruits of the Salal have been eaten fresh and preserved in a number of ways by the First People throughout its extremely wide range, from California to Alaska. Salal prefers semi-shaded portions of forest, especially spreading over the edges of trails and streams.

Salal is a low growing, sprawling shrub with shiny dark green, sharply pointed oblong leaves 5-10 cm in length. This common understory plant is browsed by deer and elk, the fruit is eaten (and the seeds are thus dispersed) by the band-tailed pigeon, and numerous song birds, squirrel, bears and chipmunk. It regenerates rapidly in disturbed areas, becoming fairly dominate after the initial flush of <u>pioneer species</u>, three to five years after logging or fire.

Can you draw a food web starting with this plant? There is an example on page 111

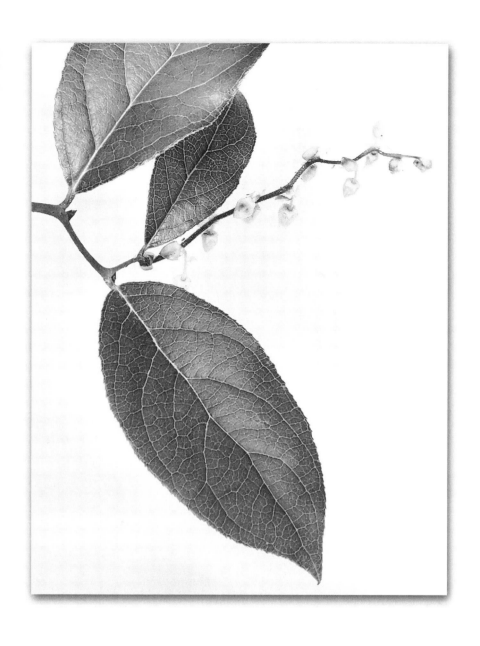

Salal
(*Gaulheria shallon*)

Elk Clover

Plants in the Ginseng Family are found in cool climates on both Northern and Southern Hemispheres, suggesting that their ancestors evolved before the great splitting of the super continents, Gondwanaland and Laurasia, some 200 million years ago. Native to Oregon and California, Elk Clover is the only North American species of this family. Despite its name, it is not a clover at all, but rather a winter dormant herb, returning in the Spring from a good-sized and succulent fleshy rootstock.

Small, greenish-yellow flowers form on the tips of branches Apr-July. They are produced in ball-like clusters 30-45 mm in diameter at the end of thick, arching, non-woody stems. The flowers mature to form small, dark purple or black berries containing three to five seeds. Take a really close look at the tiny flowers and you will see that they are made up of five petals and five stamens.

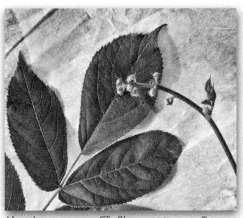

How do you suppose Elk Clover got its name?

The leaves of Elk Clover have net veins in the manner typical of the Order Dicotyledon. Its large green leaves grow alternately on opposite sides of the stems, with each made up of three to five leaflets. Elk Clover grows to a height of 1-3m along streams in Redwood or mixed evergreen forests. Birds like to eat the berries. Soon after its stems turn reddish brown, the leaves turn yellow and Elk Clover dies to the ground, to grow anew from its rhizomes the following Spring.

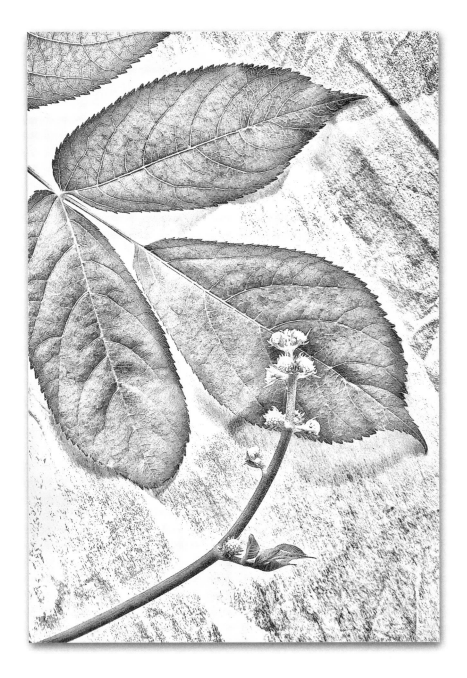

Elk Clover
(*Aralia californica*)

83

Wood Rose

This delicate beauty blooms April-Sept, producing pink flowers with five petals. When pollinated by native species of bees, Wood Rose ovaries swell and form red rose hips in Fall. Rose hips (the red fruit of rose plants) contain 24 times the concentration of Vitamin C of oranges. The English citizens gathered them from their gardens to bolster their diet which was low in Vitamin C due to shortages of food supplies during World War II. Our native rose is a more delicate species and produces fruit in a small quantity. Garden roses have been selected to have a multitude of petals not seen in native roses.

The Wood Rose has five to seven serrated leaflets to a leaf, with tiny thorns on stems. It grows best under shaded conditions in moist areas of the forest, often forming a thicket of thin stems and prickles. Wood Rose can be considered a keystone species- a species that a big effect on the other plants and animals which inhabit the area. The flowers support many pollinator species including butterflies. After blooming, wild rose hips persist on the plant and are an important food source for birds and mammals.

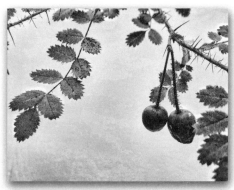

Rose hips

When I find a few firm, ripe rose hips on unprotected land, I eat them raw or dry them for making tea with a bit of honey. I have read that some folks may be allergic to rose hips, so use discretion when tasting them for the first time. When dried and sealed in a plastic bag, rose hips last indefinitely.

84

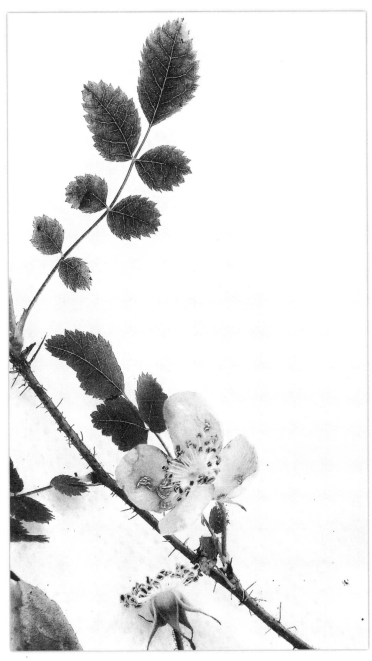

Wood Rose
(*Rosa gymnocarpa*)

Inside-out Flower

The Inside-out Flower is an amazingly different plant with small, delicate white flowers on thin stems surrounded by <u>sepals</u> and <u>petals</u> which are bent back in a flexed manner. This reveals six central white <u>stamens</u> in a very unusual windswept manner, giving the plant its common name. Inside-out Flower's thread-like flower stalks rise above foliage in late Spring, bearing drooping clusters of 25 to 50 small blossoms. Inside-out Flowers are pollinated by flies and bees.

Inside-out Flower is virtually disease and pest free. Its <u>rhizomes</u> spread slowly from an ever-enlarging mat of roots, in time forming sizable patches as an understory for the forest. Inside-out Flower grows to a height of 30 cm in shady, moist areas, often alongside <u>perennial</u> streams.

Like Vancouver Island in British Columbia, this plant's <u>genus</u> name was given to honor the British explorer, George Vancouver. Inside-out Flower ventures just a small distance north of California, closely matching the distribution of the Coast Redwoods.

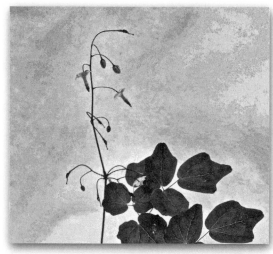

What trait does the Inside-out Flower share with the Coast Redwood?

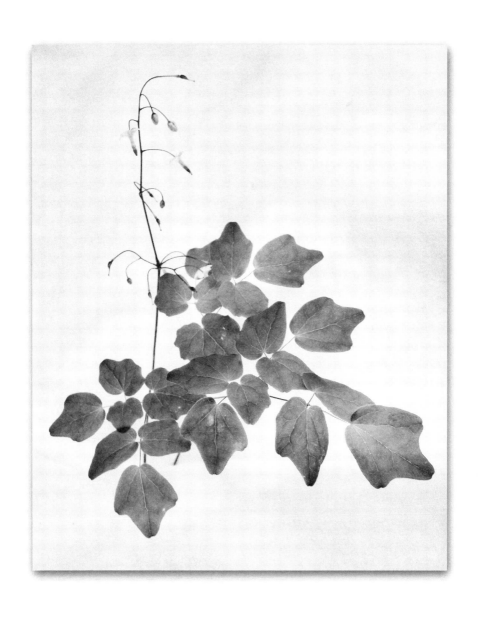

Inside-out Flower
(Vancouveria planipetala)

California Azalea

This large, visually compelling shrub's floral tresses can fill the air around the flowers with a delightful sweet and spicy clove-like fragrance. The whitish pink to yellow flaring trumpet shaped blooms sit atop deciduous branches, emerging before the leaves for maximum effect.

Western Azalea, like many Western shrubs, has the capacity to resprout from the ground if the top has been destroyed by fire, landslides, flooding, or other catastrophe, as long as the root system remains intact. After the flowers have begun to bloom, California Azalea's bright green, oval leaves appear. New leaves, buds, and seed capsules are covered with oily glands that have a spicy odor up close; these glands tend to fall off as the season progresses. The leaves turn golden yellow to scarlet in late autumn with plants that have deep pink flowers bearing leaves that turn the deepest red. California Azalea grows along streams and in damp openings of the Coast Redwood forests.

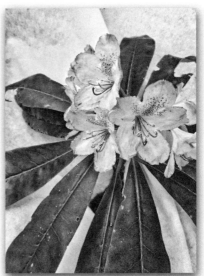

California Rhododendron
(Rhododendron macrophyllum)
What does it have in common with the Azalea?

Pollination is by bees, ants, beetles and butterflies, all of which seem to appreciate Azalea's scent as much as we humans do. California Rhododendron is a member of the same genus and is even showier! Its range is more northerly, and its leaves leathery and branches thicker. All parts of these widely grown plants are poisonous.

88

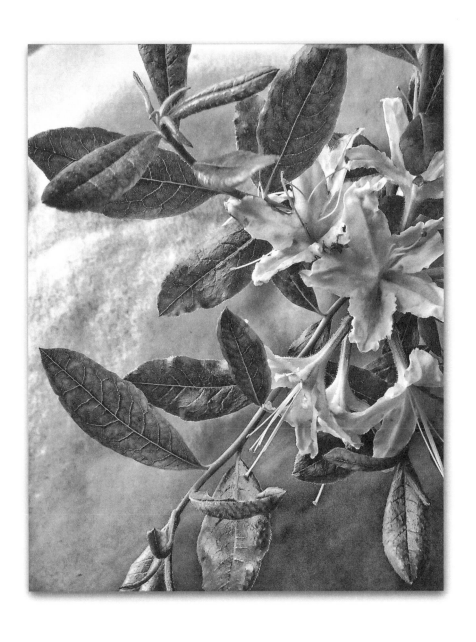

California Azalea
(*Rhododendron occidentale*)

89

Crimson Columbine

This is one of the most beautiful flowers to grace the Redwood forest! Crimson Columbine's <u>genus</u> name, Aquilegia, comes from the Latin word for eagle, referring to the spurred <u>petals</u> that resemble an eagle's talons. The <u>species</u> name formosa, means beautiful in Latin. Crimson Columbine's Orange-Red blooms are on display April-July (treeting us to a longer blooming period than most) at the edge of moist areas in the forest. The flowers are formed of five red 'hollow spurred' <u>petals</u> folded backwards and five yellow 'unspurred' <u>sepals</u>. Tiny seeds are held in dry pods over the winter to sprout in the Spring.

Crimson Columbine's thin green leaves are attached to delicate branches, providing a graceful backdrop for the fetching flower. This <u>perennial</u> stands 60-100 cm tall and blooms in its 2nd year. Like Douglas Iris, Crimson Columbine is very adaptable and hybridizes quite easily with other Columbines in gardens, producing non-native plants with a wide variety of bloom colors.

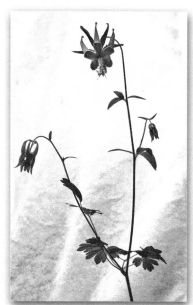

What other examples of <u>co-evolution</u> can you think of?

Hummingbirds and Sphinx moths pollinate this flower, as a result of millennia of <u>co-evolution</u>. The evolution of a deeply throated flower has provided a <u>selective pressure</u> in the pollinators to <u>evolve</u> a beak or proboscis long enough to insure the Columbine's reproduction.

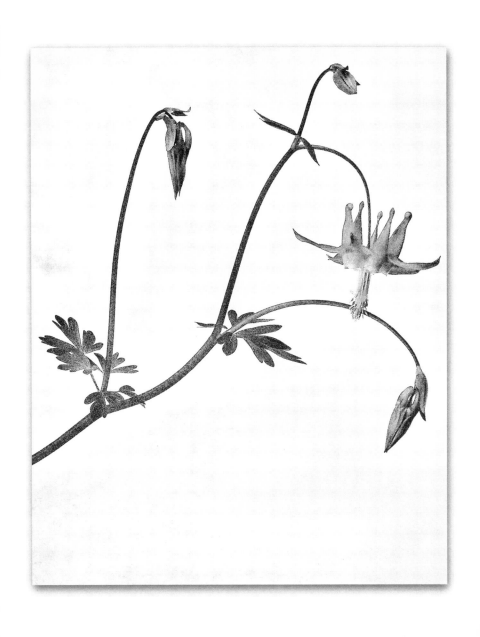

Crimson Columbine
(*Aquilegia formosa variety truncata*)

91

Yerba Buena

San Francisco was originally given the name of Yerba Buena. Later the town and the Bay's name were changed to San Francisco in honor of the mission. The name Yerba Buena continues as the name of the island that joins the two halves of the Bay Bridge, and as the name of this delightful mint. The common name, Yerba Buena, is Spanish for 'good herb'.

Yerba Buena's small leaves are aromatic and are attached to a square stem, another feature of mints. The rich green, scalloped leaves are held oppositely on the stems. Like most mints, Yerba Buena forms new roots at the nodes of

its stems when in contact with wet soil and is easily propagated. Small tubular, white to light purple flowers bloom April-Sept, and is pollinated by native bees.

Despite creeping on the forest floor, unlike most mints, Yerba Buena is surprisingly tough and long lived.

What other mints do you know?

Also in contrast to most mints is the fact that Yerba Buena's fragrance changes strongly from its young, emerging leaves of February, which have a lemon scent, to the mature leaves of June, which have the traditional minty smell. Your nose will instantly announce both the season and the presence of Yerba Buena should you step on it during one of your hikes!

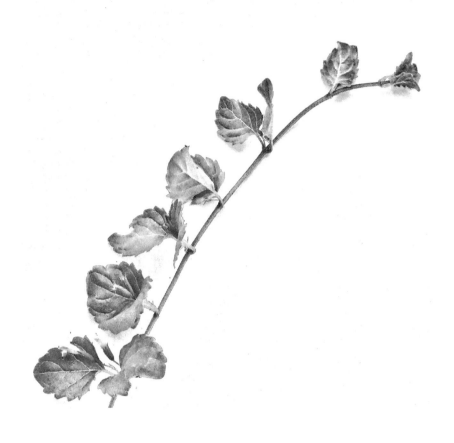

Yerba Buena
(*Satureja douglasii*)

Wood Mint

This member of the mint family forms <u>whorls</u> of pink flowers along its stems, with the flowers blooming sequentially from top to bottom Mar- July. Wood mint is also known by the name of Hedge Nettle but lacks the poisonous micro-spines of true nettles. It is a fairly common, low-growing herb which prefers moist places with partial shade. Each of the flowers in a <u>whorl</u> has an upper lip and lower lip. The lower lip is speckled with spots and much longer to serve as a landing pad designed to aid <u>pollination</u> by bees.

The <u>genus</u> name Stachys is from a Greek word that translates as "ear of grain"; this is meant to refer to the spike shape of the flowering stem. The <u>species</u> name bullata refers to the crumpled appearance of the leaves.

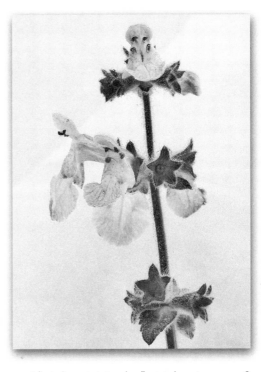

Wood Mint's leaves form a series of pairs directly opposite each other along the stem. They are thick and almost spongy to the feel and coarsely grained. Wood Mint's leaves are aromatic, and have a lemony odor when crushed. Their strong vein pattern is great for making ink prints.

What characteristics do all mints have in common?

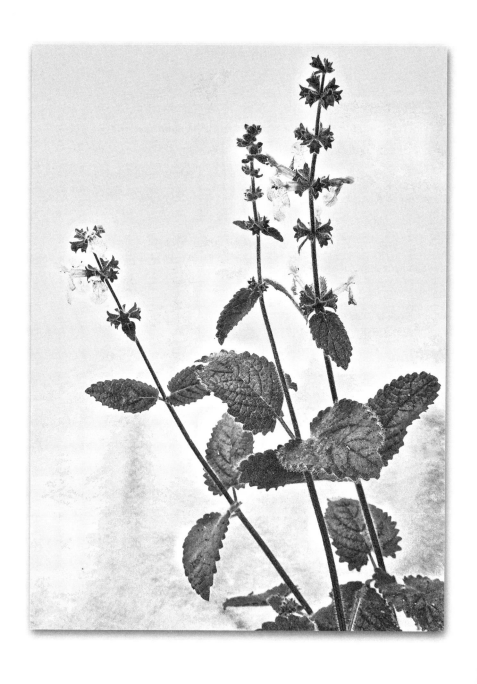

Wood Mint
(*Stachys bullata*)

95

Bracken Fern

The most widely adapted of the ferns, Brackens can inhabit everything from dry open slopes to moist sheltered areas of the coastal mountains. Turn over one of its fronds during late spring to early summer and you may see the sori that produce spores. In addition to reproducing with spores like most ferns, Bracken ferns, with their long creeping rhizomes, can extend over large areas and it may not be obvious that plants on one side of a population were physically derived from plants on another. In this manner, free from the necessity of moisture for fertilization, they are able to cover large brakes or open areas, creating a delightful miniature forest of their own design.

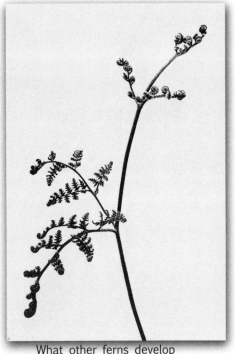

The 'fiddle-neck' shaped tips of the young fronds (less than 30 cm tall) are edible in the Spring, the good ones having a pleasant nutty flavor. As they mature, however, the taste turns bitter and they accumulate a B Vitamin-destroying enzyme, and therefore should be avoided. In 1990, the Bracken Fern was added to the list of substances know to cause

What other ferns develop 'fiddlenecks'?

cancer (esophageal). Although it is unlikely this will cause you to get cancer as people have been eating them by the cupful for centuries, I limit myself to one or two in celebration of my first Spring hike.

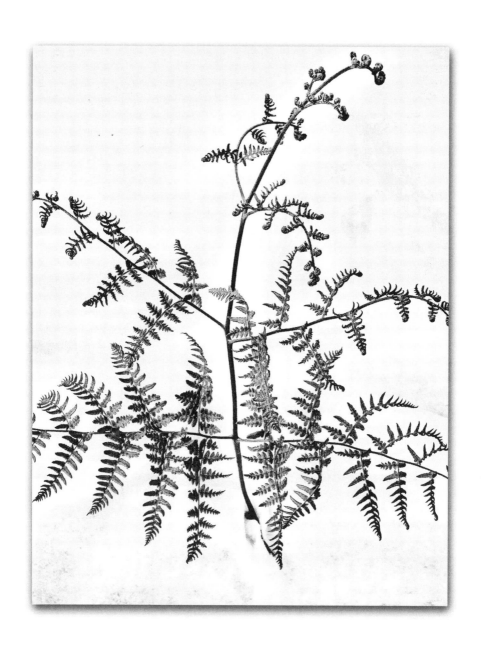

Bracken Fern
(*Pteridium aquilinum*)

97

Trail Plant

This small <u>perennial</u> has such TINY white flowers sitting atop thin, branched stems that you would never imagine that Trail Plant is in the Sunflower Family. Like other members of this very large family, each flower is composed of many small disk and ray flowers, but you would need a magnifying glass to see them. Trail Plant is pollinated by bees and prefers moist forests with full to partial sun, often forming large clusters of plants. The base of the plant is surrounded by a <u>whorl</u> of spear-shaped leaves, from which this interesting plant gets its name.

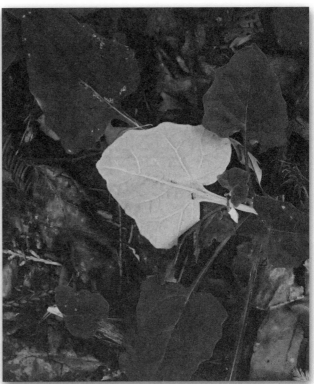

The <u>species</u> name, bicolor, refers to the very different colors of the two sides of the leaf. The common name comes from the

Which other plants in this fieldbook form whorls?

leaf's tendency to flip over when stepped on, exposing the white, wooly underside, in sharp contrast to the green and smooth upside. Inevitably, the white pointer-like leaf points to the direction which the person who stepped on it has gone.

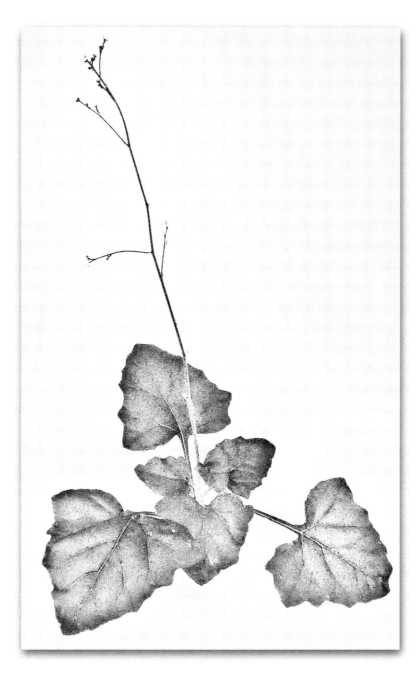

Trail Plant
(_Adenocaulon bicolor_)

Stinging Nettle

This member of the Nettle Family is important to learn, if only so that one can avoid contact with its micro-spines which at first glance go unnoticed. The Stinging Nettle's light greenish flowers bloom May-Oct, and hang in clusters from where its leaves join the stems. Stinging Nettle's large spear shaped leaves are arranged in pairs set opposite each other like arms along the stem. This perennial grows to a height of 1.5m from underground rootstocks.

Stinging Nettle prefers moist areas in Redwood forests and near streams. The stout stems contain formic acid (the same chemical employed by stinging ants and bees). After being injected by the micro-spines on the stem of the plant, the formic acid creates a strong stinging sensation which lasts for 30 minutes or so.

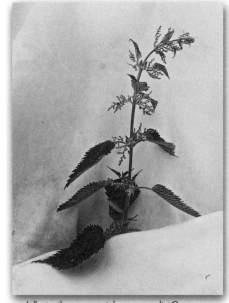

What other perennials can you list?

Brown Towhee are known to eat Stinging Nettle, and it also can be safely consumed by humans as a spinach substitute--AFTER steaming or boiling has broken down the formic acid. One of the oldest known teas is made from Stinging Nettle. A mixture of salt and a strong nettle solution can be used to make rennet to curd milk in the making of cheese. If you can take the sting, some people (including myself) rub the stem on arthritic joints, using the micro-spines to inject their histamines, thus blocking the formation of inflammatory chemicals.

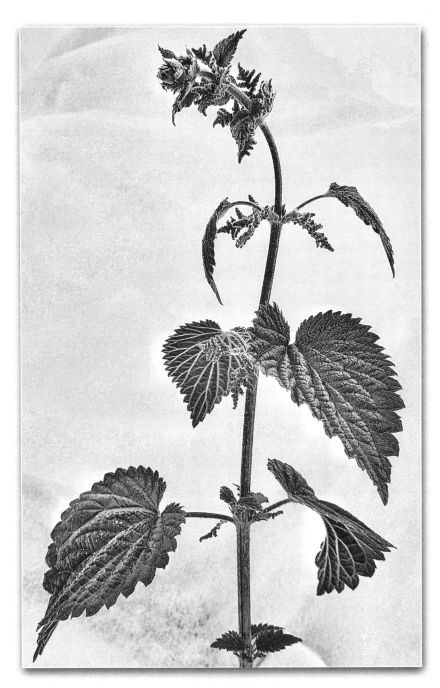

Stinging Nettle
(*Urtica dioica*)

101

Five-Finger Fern

This wide ranging fern is found throughout much of North America in wet, shaded outcroppings. The species name refers to the Aleutian Islands, the northern end of the Five-Finger Fern's range. The number of leaves rarely matches its common name. Its sori require even more moisture for fertilization than the typical fern.

This fern can reproduce with the closely related Maidenhair fern (Adiantum jordanii), producing sterile hybrid ferns. You frequently see the Five Finger Fern growing on the very edge of a small stream or moist trail cut cliff.

Take some time when you find this fern, let your eyes follow its shiny black stems and imagine the First People patiently weaving them into a pattern on the side a basket.

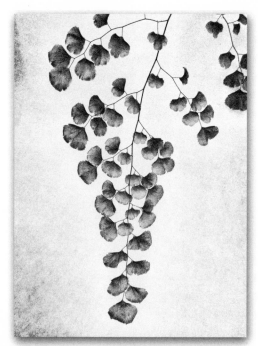

Trace its tiny veins and sense
the movement
of water molecules,
gently pulled out to the tip
of each blade.

Then, take a deep breath and
feel your pulse

 slow

 down.

Maidenhair Fern, close relative of Five Finger Fern

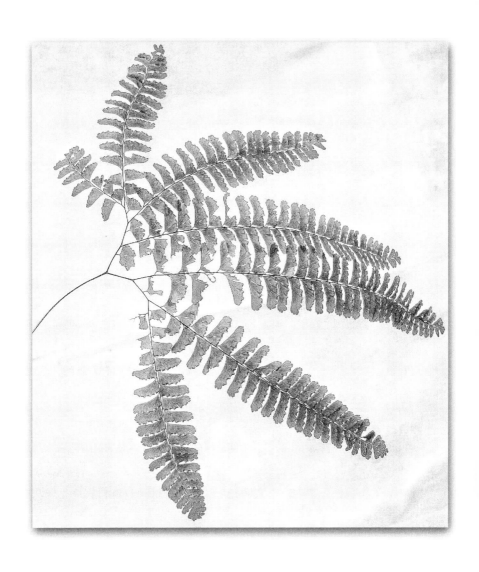

Five-Finger Fern
(*Adiantum aleuticum*)

Tan Oak or Tanbark Oak

California's First People were particularly fond of oaks. The Pomo, (who inhabited what now makes up most of Sonoma and Mendocino counties) called them "chishkale" meaning "Beautiful Tree". Acorns formed a staple in the diet of the People. They dried them whole and stored as many as they could, preserved by their high tannin content. The First People ate acorns every day, depending on them to get through hard times both before and after the coming of the White Man.

The Tan Oak's yellow green flowers bloom May to June. The acorns to mature over the next two years. You can often see nearly mature acorns on flowering branches.

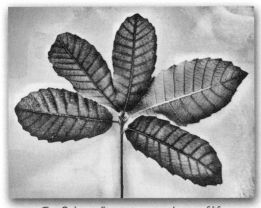
Tan Oak seedling in its second year of life

In Spring, Tan Oak's leaves are light green and shiny on the top sides, and reddish and wooly on the underside. By late summer, the hairs have been lost and the bottom surface is whitish. Tan Oak grow to a height of 17-30m in the shaded parts of the forest, but in deep shade a short shrub form is produced. With flowers similar to chestnuts and acorns similar to oaks, this extraordinarily handsome and useful tree is an interesting evolutionary experiment related to both groups as recent DNA analysis bears out. The Tan Oak is often co-dominant with the Coast Redwood and, like the Redwood, its leaf litter tends to keep other plants from sprouting beneath it, probably due to its acidic nature. 104

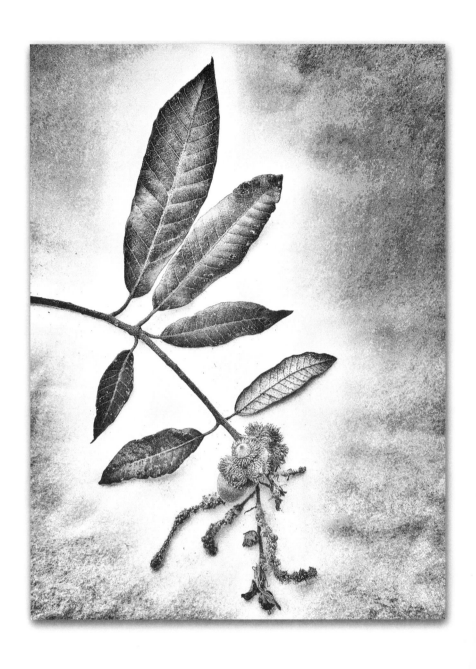

Tan Oak
(*Notholithocarpus densiflorus*)

105

Mugwort

Mugwort is often found growing near Poison Oak and has been used as a poultice to combat its itching. It belongs to the Sunflower family, and, with 20,000 species world wide, it is clearly one of the best adapted of the plant families! Mugwort blooms in whitish yellow-grey green June-Nov. With a hand lens, you will see that the flowers are composite in structure, with disk flowers grouped in the center, surrounded by single petaled ray flowers in the same manner in which its relative the sunflower is constructed, just on a much smaller scale.

Mugwort is found along streams and trails in disturbed areas, from sun to partial shade. The leaves of Mugwort are pungent and they are sometimes burned as a sage substitute. Mugwort has been attributed with a wide range of medicinal and recreational uses. Medieval herbalists made a tea from its flowers and buds, claiming it caused dreams of the future. Mugwort is also used to repel moths from wool clothing. Mugwort likes to grow in

Mugwort leaves make good ink prints

colonies. Living on the edge of Redwoods, one of my garden beds has been recolonized by Mugworts. I used to grow potatoes there, but the Mugworts have been persistent in reclaiming that patch of land that was Redwood forest over a century ago. I am inspired by nature's ability to use a succession of plants that have evolved over the millennia, to heal the wounds we humans have inflicted. As a lifelong student of nature's work, I welcome the seedling Mugworts, Wood Mint, Redwood, Maple and Madrone trees that have sprung up on the edges of my small farm over the quarter century I have lived here.

106

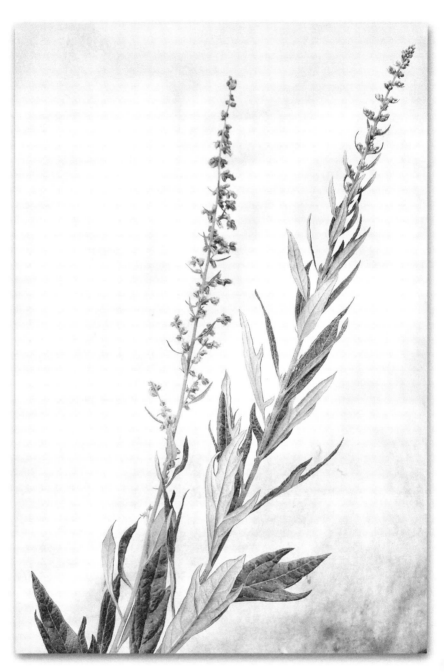

Mugwort
(*Artemisia douglasiana*)

A REDWOOD COMMUNITY FOOD WEB

Food webs diagram the movement of food within a community. This one shows
ways food moves through living things dependant on the Tan Oak.

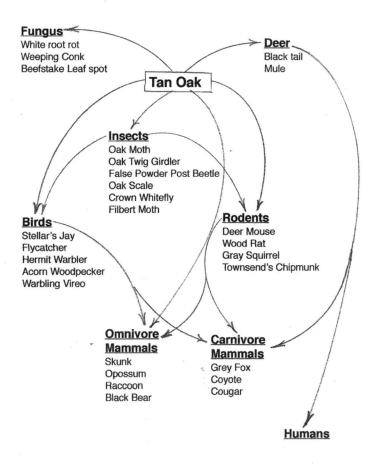

Fungus
White root rot
Weeping Conk
Beefstake Leaf spot

Deer
Black tail
Mule

Tan Oak

Insects
Oak Moth
Oak Twig Girdler
False Powder Post Beetle
Oak Scale
Crown Whitefly
Filbert Moth

Birds
Stellar's Jay
Flycatcher
Hermit Warbler
Acorn Woodpecker
Warbling Vireo

Rodents
Deer Mouse
Wood Rat
Gray Squirrel
Townsend's Chipmunk

**Omnivore
Mammals**
Skunk
Opossum
Raccoon
Black Bear

**Carnivore
Mammals**
Grey Fox
Coyote
Cougar

Humans

UPON BEING CONNECTED

"If one day I see a small bird and recognize it, a thin thread will form between me and that bird. If I just see it but don't really recognize it, there is no thin thread. If I go out tomorrow and see and really recognize that same individual small bird again, the thread will thicken and strengthen just a little. Every time I see and recognize that bird, the thread strengthens. Eventually it will grow into a string, then a cord, and finally a rope. This is what it means to be a Bushman. We make ropes with all aspects of the creation in this way."

-San Bushman of the Kalahari desert

everything changes
everything is connected
pay attention

-Zen saying

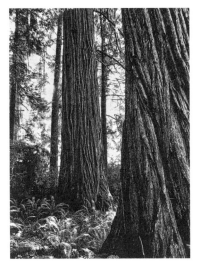

On a field trip long ago, the leader told the group that it was his goal to cure the participants of what he called, "the green blurs". He said he wanted them to see the individual plants they share the planet with, and not just the amorphous green that most people see. That choice made all the difference.

-DC

109

SUGGESTIONS FOR HAND TINTING

It is best to hand tint In The Company of Redwoods plates while looking at the actual plants as you find them in bloom in the Redwood forest. But what if they are not blooming the day of your visit? In that case, you can either wait until you find them in bloom or consult the Color Galleries on my website for the appropriate colors.
www.inthecompanyofredwoods.com

While its gray scale images are pleasing in their own right, this Fieldbook and the accompanying Note Cards were designed to be colored to maximize the learning experience. Much is written about colored pencil techniques in books and online articles that you may want to research. Listed below are my own humble suggestions.
1-Practice on a sampler printout from the website.
2-Add color slowly and err on the subtle side by stopping early.
3-Work from the tips of leaves or flowers, following the veins you see as you move into the center of the plant.
4-Don't try to color to the very edges of a leaf, stem or flower, but start back a bit in the gray of the margins of the picture for safety. In a traditional coloring book, the idea is to color right up to the edge of the black line, and mistakes are easily made by crossing it. However in this book, the pictures are what is called 'grayscale'. This means that you can stay a safe distance back and let the gray shades on the page 'fill in' to the edge.
5-You may be interested in trying water color pencils and using a fine tipped, moistened watercolor brush to blend your pencil strokes and/or colors. You will find that the color on the page is intensified when moistened, and you may need to scale back you application of color pigment in preparation for the water. The resulting image is quite often an improvement over dry pencil color, and seems to reveal the veins and other fine details better. Its kind of like that moment in The Wizard of Oz, when Dorothy steps from the black and white world into the land of color.

THE PHOTOGRAPHIC PROCESS

I made these photographs over an entire year, searching trails throughout the range of the Coastal Redwood to capture the essence of the plants associated with the great tree. For months, my backpack was filled with an assortment of white draping and shade cloths, clothes pins, notebooks, tripods, and cameras. With these tools I set off once a week to locate superb examples of the plants I have included in this book. Not all plants are natural models. In many, the veins show weakly, the proportions are distorted or the contrast is difficult. I passed over those with insect damaged leaves, poor posture, and blooms not quite at their peak. When I found a plant that might work, I gently placed the hole in the drape cloth over it, providing a stage with nothing to distract the eye. For the taller plants, I built PVC pipe scaffolding draped with additional cloth. I used a heavy but infinitely adjustable tripod to put my camera in just the right position. A typical shoot would take me half an hour or more. The simple elegance of these plants as seen through my lens often took my breath away. As the sun came through the forest canopy, I would shade my plant 'model', my tripod and camera and myself under a large translucent cloth. Occasional hikers would comment on the sight, and who could blame them (see pg. 121, where I am shooting the picture for the False Solomon Seal found in this book). After many hours of this, I would return home or to my campsite. There I selected the best images and removed color (desaturated), cropped, adjusted contrast, grain, brightness, etc., until I felt photographic justice had been achieved.

NATIVE PLANT PROTECTION

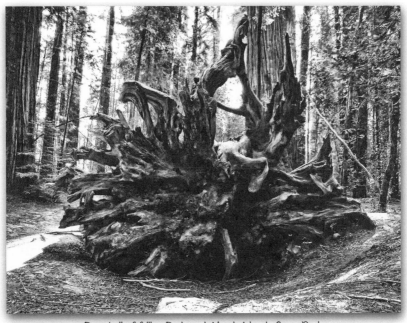

Root ball of falllen Redwood, Hendy Woods State Park

Despite the pressures associated with being the most populous state in the country, over 46% of California is preserved from development. I hope that you are able to spend many days in the national, state and local parks that protect plant and animal habitats throughout California. In this fieldbook I have included information concerning plant uses as food or material sources by the First Native American People and the Settlers that followed them. A more complete listing can be found at my web site:

inthecompanyofredwoods.com

HOWEVER, let me remind you that it is an offense to collect ANY plants from a state park, preserve or private land without a permit. The very purpose of this book to engender reverence and kinship with the plants you learn. Native plants need our protection. Collect memories and knowledge of these plants, and become their guardians.

112

PLANTING YOUR OWN "BEAUTIFUL TREE"

A slow grower, Tan Oak trees usually begin to bear acorns in the fifth to thirteenth year. Older Tan Oaks produce huge numbers of acorns, providing food for insects, birds, rodents, deer, bear, and raccoons. The first acorns to fall are usually infested by insects, so, if you want to sprout or eat some, gather those that fall in October. To grow them, plant acorns 3 cm deep with the pointed end up in good soil and keep them moist but not soaked. Seedlings appear about 3 weeks after planting.

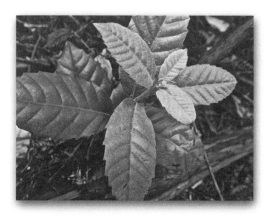

Tan Oak
seedling in its
second year
of life

PREPARING ACORN MEAL

1-Remove the outer shells, dry the kernels, then rub off the bitter red husks.
2-Grind and crush the kernels into a meal or flour (depending on if you are making soup or bread)
3-Place in cheesecloth, an old clean sock, nylons or tights and secure to an outdoor faucet where the water can be diverted to a plant that might benefit.
4-Turn the tap on so that it drips slowly overnight or until the bitterness is completely gone.
5-Cook the leached acorn meal with butter and garlic (added before the acorn meal) by simmering for 10 minutes on medium heat to evaporate the water and cook the meal.
6-Add salt to taste and serve. 113

BOTANICAL USES

Common Name	Use	Who
Milkmaids	oddly shaped roots eaten	1st People
Solomon Seal	fresh roots can be ground up and used as a poultice for stings, bites, Poison Oak and Stinging Nettle	1st People, Settler
Horsetail	silica rich stems used as scouring brush	Settler
Bay	vaporizer for colds, disinfectant, as a rub down in sweat lodges a deterrent for fleas Hardwood by cabinet makers and lathe workers	1st People Current
Hound's Tongue	taproot used to make a salve for burns and a remedy for stomachache	1st People
Miner's Lettuce	eaten raw in salads and boiled like spinach. A laxative tea can be made from its leaves	1st People, Settler
California Polypody	boiled roots and leaves to treat internal bleeding	1st People
Chain Fern	stems (both naturally and dyed red with alder bark) used in basket weaving	1st People
Violet	used to make tea, flowers to flavor candy	Settler
Redwood Sorrel	sour stems used to make a pie similar to rhubarb	Settler
Flowering Currant	edible raw, cooked into jams or dried, used to make pemmican combining with animal fat for a high energy food for use in the winter or when hunting	1st People
Wild Cucumber, Manroot	roasted seeds eaten for kidney troubles. Oil from seeds was used treating hair loss Large round seeds used by the children of Spanish settlers for marbles	1st People Settler
Madrone	orange fruits eaten fresh or roasted, Summer bark peels boiled make a tea for stomachache, sore throat	1st People
Maple	branches used in a dice game Related to the Eastern maple, its sap made into syrup, wood is fine grained	1st People Settler
Wild Ginger	dried roots used as a spice. Candy was made by boiling the roots with sugar	Settler

BOTANICAL USES

Common Name	Use	Who
Douglas Iris	side ribs of the leaves used to make string, rope, hunting snares and nets	1st People
Huckleberry	Iroquois tribe smeared huckleberries on their moccasins to repel rattlesnakes! Ripe berries are excellent raw or cooked	1st People Current
California Blackberry	berries can be eaten raw or cooked into pies, young shoots can be sliced in salads	Current
Thimbleberry	women rubbed leaves into their cheeks to redden them as a makeup technique	Settler
Douglas Fir	tea from the needles used for lung trouble, pitch as glue, wood for fires, smoke to disguise scent for hunting and for rheumatism	1st People
Wood Rose	used a tea from rose hips for cold relief	1st People
Hedge Nettle	leaves soaked in water reputably good for healing wounds and sores	1st People
Tanbark Oak	need more leaching than other acorns, but resulting oak meal has a great taste, is rich in oil and well suited for soups and breads. Bark stripped the from tree and boiled releases tannic acid for use in tanning leather	1st People Settler
Ceanothus, Wild Lilac	flowers and leaves are used to make tea, leaves and roots for a red dye and stems as foundations for baskets	1st People
Bracken Fern	roots used to make baskets, water boiled by placing fire heated rocks in them to make soup which could be thickened by adding the young tips of their fronds	1st People
Stinging Nettle	made a delicious tea good for digestion	Settler
Five-Finger Fern	stems woven into a pattern on the side of baskets	1st People
Mugwort	poultice of boiled leaves used to treat skin rash caused by poison oak, also used to treat colds, headache, cramps	1st People

PLANT GROUP CHARACTERISTICS

ORIGIN	GROUPS	CHARACTERISTICS	REPRESENTATIVE
360 mya	FERN DIVISION	no flowers, reproduce by spores	
	Horsetail Family	spore produed by cone at top of grooved, segmented stems	Horsetail
	Polypody Family	single row of sori on both sides of midrib, rounded blade-like 'leaves'	California Polypody
	Deer Fern Family	sori oblong, in pairs	W. Chain fern
300 mya	Braken Family	wide trianglular fronds, can form dense groups	Bracken Fern
	Wood Fern Family	serrated blade like 'leaves', round, tightly packed sori	W. Sword fern
	Brake Family	leaflets on thin shiny black stalks	5 Finger Fern
	GYMNOSPERM DIVISION	naked seeds in cones	
	Cypress Family	alternate, awl shaped needles	Redwood
	Pine Family	needles encircle stem	Douglas Fir
65 mya	ANGIOSPERM DIVISION	flowering plants	
	DICOT DIVISION	2 seed leaves, netted leaf veins, flower parts in 4's and 5's	
	Pipevine Family	aromatic leaves, stems, rhizomous	Wild Ginger
	Laurel Family	aromatic, alternately simple leaves	California Bay
	Sumac Family	cause skin rash	Poison Oak
	Carrot Family	annual, flattened umbrella like head of small flowers with 5 petals	Cow Parsnip
	Ginseng Family	deciduous shrub, flowers 5 petals	Elk Clover
	Sunflower Family	Composite flowers: tube shaped disks in center, ray type on edges	Trail Marker Plant, Mugwort
	Barberry Family	perennial with rhizomes, 6 petals	Vanilla Leaf
	Birch Family	deciduous trees, catkins appear before simple alternate leaves	California Hazel
	Borage Family	rosette of lvs around base, annual	Hound's Tongue
	Mustard Family	4 petals in shape of cross, seeds develop in a long thin pod	Milkmaids
	Gourd Family	climbing annual, 5 petal fused cup	Wild Cucumber

PLANT GROUP CHARACTERISTICS

ORIGIN	GROUPS	CHARACTERISTICS	REPRESENTATIVE
	Heath Family	shrub or tree, bell shaped flower	Madrone, Salal
	Oak Family	trees produce acorns	Tan Oak
	Gooseberry Family	shrub, alternate leaves, berries	Currant
	Mint Family	square stem aromatic	Wood Mint
	Miner's Lettuce Family	fleshy leaves and stems, shiny seeds	Miner's Lettuce
	Myrsine Family	annual, 5-7 petals	Pacific Starflower
	Oxalis Family	annual, compound leaves, 5 petals	Redwood Sorrel
	Buttercup Family	annual, leaves around base of plant	Columbine
	Rose Family	shrub, tree, 5 sepals	Wood Rose
	Soapberry Family	shrub to tree, palmate leaves, winged fruit	Big Leaf Maple
	Saxifrage Family	rosette leaves	Brook Foam
	Nettle Family	stinging hairs, green flowers	Hedge Nettle
65 mya	**MONOCOT DIVISION**	1 seed leaf, parallel leaf veins, flower parts in 3's or multiples of 3	
	Lily Family	perennial from bulb or rhizome, 3 or 6 stamens	Red Clintonia
	Iris Family	perennial bulb, rhizome, sword shaped leaves	Douglas Iris
	False Hellbore Family	flower pts.in 3's, bulb, rhizome	Trillium
	Butcher's Broom Family	perennial red or blue-black berry	F. Solomon Seal
	Grass Family	fibrous roots, small green flowers, wind pollinated	C. Sweet Grass

GLOSSARY

term	working definition
cm	centimeter, a little more than 1/2 inch
coevolution	the process by which multiple species adapt over time in response to changes in each other
compound	a leaf that is made up of more than one leaflet
dicot	short for dicotyledon, a plant that forms its first two leaves inside the seed
dioecious	having the male and female reproductive organs in separate flowers on separate plants
evolve	to change over generations to a form that better fits its environment
First People	Native tribes of the 'New World'
frond	the leaf of a fern
genetic diversity	the range of population's adaptations to its environment
genus	a group of closely related species
germination	the sprouting of a seed
gymnosperm	the group of plants without seed coverings, includes pine and Redwood
hermaphroditic	a flower that has both pollen-producing and egg-producing parts.
keystone species	a species that has a disproportionately large effect on its environment relative to its abundance
m	meter, a little more than 3 feet or 1 yard
monocot	short for monocotyledon, a plant that forms only its first leaf inside the seed
ovary	female egg producing organ, eggs pollinated by pollen become seeds
palmate	describes leaves shaped like an open palm with the fingers outstretched
perennial	plants that live three or more years, also streams that flow year round

GLOSSARY

term	working definition
petal	parts of a flower surrounding the reproductive organs, usually colorful
pinna	leaf like part of the fronds of a fern
pioneer species	first species to colonize previously damaged habitats
pollination	pollen transfer from male stamens to eggs in ovary
raceme	a flower cluster with the separate flowers attached by short stalks at equal distances along a central stem
rhizomes	fleshy underground stems that grow parallel to the ground, can sprout new plants
riparian	a stream or river bank habitat
rosette	a circular arrangement of leaves, with all the leaves at a similar height
scientific name	unique italicized Genus + species name of a living thing, ex. *Homo sapiens*
selective pressure	a factor in the environment that causes a population to change genetically
sepal	petal-like structures that protect a growing flower bud, usually green
sori	spore producing organ on the underside of a fern frond
speciation	nature's process of creating a new species from a successful variety
species	a group of plants so closely related that they can interbreed
stamen	male pollen producing organ
succession	the gradual and orderly process of change in an ecosystem brought about by the progressive replacement of one community by another until a stable climax is established
whorl	leaves that grow from a single location on a stem

Index

120

Index

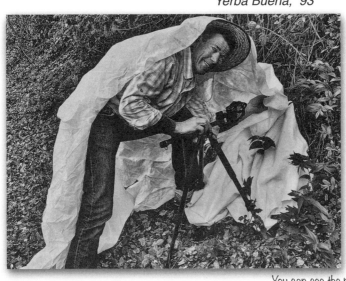

You can see the picture I was
taking on pg. 24

RESOURCES

Fieldbooks, hand tintable notecards and additional copies of the plant images in this book may be ordered via my website:
inthecompanyofredwoods.com

Teachers and non-profit environmental and art organizations: Contact me for deeply discounted materials.

On the website I also provide color pictures for reference, My Blog as well as environmental group contact info.

Reference Books:
Baldwin, Bruce G. 2012. The Jepson Manual: Vascular Plants of California, Second Edition. UC Press, Berkeley, CA

Lyons, Kathleen and Cooney-Lazaneo, Mary Beth. 2003. Plants of the Coast Redwood Region. Shoreline Press, Soquel, CA

Thomas, John H. 1961. Flora of the Santa Cruz Mountains of California: A Manual of the Vascular Plants. Stanford University Press, Stanford, CA

I encourage you to learn more about nature and art. Search the Internet and libraries for useful information on the Internet on hand tinting technique and the plein air movement. Take a field course in botany or go on a docent or ranger lead hike. Very satisfying activities often sprout from seeds planted in this way. Explore nature as often as you can, and share what you learn!

For more about Redwoods and to help protect the Redwood habitat, contact Save the Redwoods League at:
114 Sansome Street, Suite 1200 info@savetheredwoods.org
San Francisco, CA 94104-3823

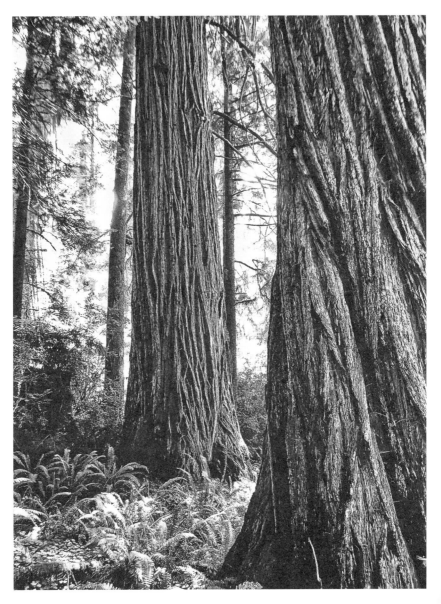

Old Growth Redwood, Prairie Creek Redwoods State Park

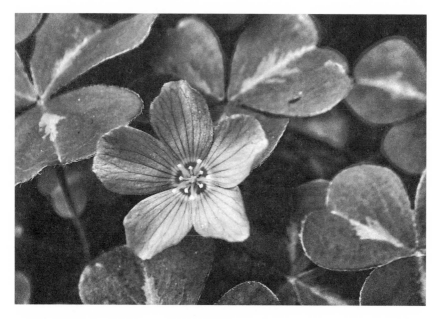

Redwood Sorrel, Muir Woods National Monument